EMILY CARR AS I KNEW HER

Emily Carr
As I Knew Her

CAROL PEARSON

forewords by Robert Amos
and Kathleen Coburn

TouchWood
Editions

Cover art by Robert Amos
Cover design by Pete Kohut

LIBRARY AND ARCHIVES CANADA CATALOGUING IN PUBLICATION
Pearson, Carol, 1910–, author
Emily Carr as I knew her / by Carol Pearson ; with a foreword by
Kathleen Coburn, M.A., B.Litt. (Oxon.), F.R.S.L.

Reprint. Previously published: Toronto : Clarke, Irwin & Company Limited, 1954.
Issued in print and electronic formats.
ISBN 978-1-77151-174-2

1. Carr, Emily, 1871–1945. 2. Pearson, Carol, 1910–. 3. Women painters—
Canada—Biography. I. Coburn, Kathleen, 1905–1991, writer of foreword II. Title.

ND249.C3P43 2016 759.11 C2016-900240-3

We acknowledge the financial support of the Government of Canada through the Canada Book Fund and the Canada Council for the Arts, and of the province of British Columbia through the British Columbia Arts Council and the Book Publishing Tax Credit.

 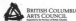

The interior pages of this book have been printed on 100% post-consumer recycled paper, processed chlorine free, and printed with vegetable-based inks.

PRINTED IN CANADA AT FRIESENS

16 17 18 19 20 5 4 3 2 1

CONTENTS

FOREWORD

The little room under the eaves! It was no wonder that this was her favourite or, as Miss Carr said, "mostest favourite" room! Yet every time I stayed with her, if only for a night, she would make it up fresh, and insist that I use it. The first two years after I met Miss Carr, she was my teacher, in art and modelling [in clay]. As our relationship developed, the teaching was only an incident. She was like a fairy Godmother, complete with animals, whom I loved completely, a childish worship if you like, but she returned my love. After the first year I was her guest from time to time, casually, but after two years she asked me to move right in, and the small room was then known as "Baboo's eyrie." She never used it again, after I left the West to be married. "All things come home to roost, Baboo; it will be ready when you come," she said.
 Carol Pearson, *Emily Carr As I Knew Her*, p. 144

ALL the scholarship and research that have accumulated since her time adds to our appreciation of Emily Carr, helps us understand her place in society and the messages she conveyed

in words and pictures. But what was she really like? That's what we want to know. And there is no better guide than Carol Pearson. Pearson was a child herself, and Carr was as an eternal child of wonder. Later, when Carr's painting days were past, her animals were all gone, and Carol had grown and married, she was there again with Emily Carr.

Emily Carr died in 1944, and it must have been soon after that time when Carol Pearson sat down to write her memoir of what had happened between them from 1920 and 1944. It was her first book, and a surprisingly good one it is. It seems she wrote it with Emily Carr's writing style as a guide—never use two words when you can say it in one, and never use a long word where a short one will do. The prose is effortless, and generous with the reader.

For many years, Emily Carr seemed to have lost the joy of life that was so evident in her stories in *The Book of Small*. Orphaned at sixteen years old, she didn't have the guidance and support of her parents while facing the emotional and economic struggles of a young artist. Her older sisters either ignored her ambition or tried to curb her efforts, believing that the life of an artist was not appropriate for someone of her social standing and God-fearing upbringing. Among the Victorians of the day, they were not alone in this attitude.

After a long struggle, when Carr was in her forties, she built her own little apartment building on Simcoe Street in 1913, the "House of All Sorts" of her later book. But as an income generator and as a refuge for an artist it was useless; she had no privacy and no time to paint. The economic

realities of being a landlady put her in a position she did not enjoy. Those golden days of childhood were long gone.

Then little Carol moved to the neighbourhood with her parents. The best source of information about Carol Pearson (née Williams) is Maria Tippett's book *Emily Carr: A Biography* (Oxford University Press, Toronto, 1979). Tippett, who interviewed Pearson and read her correspondence with Carr, says the Williams family moved from Toronto to Victoria around 1920. Carol was enrolled at Queen Margaret's School in Duncan, where she boarded.

In the summers, when her parents returned to Ontario, she and her brother stayed in Victoria at Alice Carr's little school. Little Carol took art classes from Emily Carr, and the two found a deep and immediate sympathy. As Carr later told Ira Dilworth, it was "love at first sight." In subsequent summers, Carol lived with Emily, sharing a friendship both innocent and profound, and Carr regained her joy of youth.

On her property on Simcoe Street, Carr had raised English sheepdogs—"bobtails." This was a commercial enterprise, and between 1917 and 1921, Carr raised more than 350 of these large dogs. When some of her property was sold, she turned her attention to the smaller griffon dogs. Emily and Carol shared a profound rapport with animals, and Carr taught her all she could about dogs.

They walked the dogs at Beacon Hill; they searched for clay at building sites and then worked on Carr's Klee Wyck pottery; they went on sketching expeditions up the east coast of the island, taken there by gas boat by First Nations elders.

As Maria Tippett has written, "Carol wanted to be an artist like Emily, who gave her painting lessons, often on the Dallas Road cliffs. Alongside her young pupil, Emily was herself spurred on to paint more."

Carol called Miss Carr "Mom," and was called by her "Baboo." Her concern in this book is not so much Carr's painting as her way with words and ideas, and the warmth of their loving relationship.

At age eighteen, Carol married William Pearson, and they moved to a horse farm north of Toronto. Miss Carr arrived to visit the newlyweds in 1927, at a key juncture in her artistic career. Carr had been "discovered" by Marius Barbeau of the National Museum in Ottawa. At the time, her paintings—and rugs and pottery—made a striking centrepiece in his exhibit of native art and paintings of the West Coast, held in Ottawa, and at the Art Gallery of Toronto. Carr came east for the show. Her efforts were utterly vindicated, and at this time she met Lawren Harris and the Group of Seven. Between Ottawa and Toronto, she stayed with Carol, and returned again for subsequent visits with the Pearsons.

During her last years, when Carr's health was declining, Carol was summoned to the West, and Miss Carr sent her the tickets. Reading Carol's book, *Emily Carr As I Knew Her*, enables you to accompany her as she pushes Miss Carr, warmly wrapped up and sitting in a wheelchair, as they return again to Dallas Road. The author shares her thoughts and feelings about the dogs, the monkey Woo, and the artist who was her friend. Carol was with Miss Carr almost to the end.

Do we need another book about Emily Carr? She herself provided more than enough information about her life and thoughts. Yet, perhaps for literary effect, she does not present herself in the best light. Since her death, all her journals, and even the "outtakes" from her journals, have come into print. But the extreme close-up of the self-portrait lacks the perspective a loving friend can bring.

Subsequently, others have written about Carr, a woman I consider Canada's most important artist. Edythe Hembroff came into Carr's life around 1930 after returning from her art education in San Francisco and London, which strangely paralleled Carr's own studies. Edythe accompanied Carr during her sketching trips around Victoria in the 1930s, and the word pictures she paints in her book *M.E.: A Portrayal of Emily Carr* (Clarke, Irwin & Company, Toronto, 1969) are invaluable. Later, in her book *Emily Carr: The Untold Story* (Hancock House, Saanich, 1978) Hembroff wrote that Carol was "an affectionate friend of Emily's, but one should not forget that she is a fantasist who has written a shockingly untruthful book . . . I emphatically dispute the fairy tales she relates in her book about her very special 'secret' relationship with Emily."

While the odd fact may be disputed, Hembroff's comments seem spurred by jealousy. In her biography, Maria Tippett commented, "If Emily expected to find in her another Carol Williams, she was disappointed. Hembroff was older, she did not possess the childlike spontaneity . . . nor was she as passionately fond of Emily's creatures." Perhaps Hembroff's

intemperate comments kept Carol's book out of print for many years.

I discovered a tattered copy of the 1954 edition years ago and have read Carol's book numerous times, both to myself and aloud to my painting companions at Mount St. Mary Hospital, where I conduct an art group. I found it utterly engaging, and asked TouchWood Editions to consider bringing it back for us. Once again we can share the best of all character studies of an artist each of us seems to know—in Carol Pearson's *Emily Carr As I Knew Her*.

<div align="right">Robert Amos, RCA</div>

Emily Carr
As I Knew Her

To my mother
Lenore Dennis Williams

FOREWORD TO THE 1954 EDITION

THE word *genius* is one to be used sparingly, if indeed it has not been so misused as to have no meaning at all. And perhaps we do well to forget an epithet that has often separated the artist or the scientist from his fellow-men. Yet if we use *genius* as a word to fall back on when the quality of the human vision and the urgency and power of its expression arouse our astonishment and awe so as to defy analysis, then I think there is no Canadian imaginative artist to whom it can be more spontaneously and truly applied than to Emily Carr. One quality prominent in genius is the childlike nearness to the primal source of things, the eye fresh to the wonder of the universe, the constantly inquiring mind, and—in the widest sense—the uncorrupted heart. When this essential innocence-wisdom is driven to communicate and highly endowed, to a degree highly inconvenient to itself, were happiness and social ease the aim, we get an Emily Carr.

Such characters are difficult to write about. The absence, since her death nearly a decade ago, of any book of biography or reminiscence makes this evident. But these unpretentious, artless pencil sketches walk over all the difficulties by not

3

noticing them. These are undoubtedly the most personal day-to-day stories we shall ever have about her. Here are tumbled forth, with ardour, and humour, and a vivid immediacy, the impressions she made first of all on a child, and then, periodically for twenty-five years, in a relation of unflagging respect and affection. The child had never heard of Boswell (nor was Emily Carr, though quick of tongue, a talker); nor had she any notion of the recognition that was to come. It is obvious that she knew clearly, with the stormy anger of a child smarting under injustice, that recognition was due and that understanding was being withheld. But this book is not a defence of Emily Carr as an artist, nor a comment on her work, except obliquely. Nor is it a new and unknown Emily Carr we see here. A lonely, fiercely gentle woman, fond of children, Indians, animals, and all outcasts, proud, hurt, impatient, blunt, amusing, difficult, and Klee Wyck, the Laughing One—this is a person we know. Her gaiety and quickness of wit is delightfully underlined in these pieces, with some choice specimens of it—and we see for the first time Emily Carr, educator. But Carol Pearson's book gives us more particularly the inner sense of her, as only one who is willing to share privacy can give it. For this is a work of sentiment—"a little journey into the heart," as Sterne called his *Sentimental Journey*.

In an indirect way we get a heightened feeling of that terrible driving energy, that self-crucifying, self-expressing integrity that gave her painting its strange mixture of impersonality and intense subjectivity, a compelling power compounded of a sense of vastness, and a sense of intimacy.

4

Real intimacy has not been a predominant quality in Canadian painting and writing, but Emily Carr certainly knew that by the paradox of its nature it is capable of coming to terms with forces of great magnitude. The forest paintings are full of this, and many of the Indian paintings: the little white human church and the overpowering forest jungle all around; the Indian bear totem, sign of human effort (and as such tenderly described in *Klee Wyck*), all but submerged in a sea of swirling grass as nature takes over; or the awe-struck and awe-inspiring Indian figures seen at Blunden Harbour against the darkening Pacific seascape. The immensity of the universe and the frailty and dignity of the creatures on it—this is to my mind one of her central themes. And this she conveyed to her pupil.

Here we see Emily Carr in that reciprocal relation she knew how to establish with the creatures, mostly four-legged. Of the two-legged species, she liked best children and birds. This is a book about Emily Carr with the young, and it hints at the outlook of Emily Carr and the young on the conventional or stuffy—to wit, those "customers'" chairs on pulleys! It must strike every reader that not only was Emily Carr at her freest in these relationships, but that we are being given a report of them by one who was unusually sensitive to them.

There is here that almost uncannily direct and acute awareness of what was really going on that belongs to what Blake called Innocence; this is what to my mind gives these personal and sometimes sentimental anecdotes their unique value. No one else saw Emily Carr in just this way—as pupil,

5

goddaughter, member of her household for months at a time. And yet the external facts of the relation do not explain this book. As we feel the flicks on the skin from these stories, we soon grow aware that the active receptivity of this "child" was extraordinary.

Good books have often been written by people who were not writers. Carol Pearson makes no claim to be one. (After all, she did not go on with that correspondence course, and "Mom" did!) A professional writer would have pruned many a phrase, and dramatized more fully many an incident in this book. But it is in fact in the completely non-professional, non-literary character of it that its special quality and charm lies.

Carol Pearson's art is the training of horses, for which she has a reputation not confined to Canada, nor indeed to the American continent. From Emily Carr she says she learned much that she knows about animals. She has brought up baby giraffes, and has administered injections to grateful lions for equally grateful keepers. She knows the tones of voice of an unhappy horse, and the precise meaning of the twitching of a sleeping dog's nose. She clearly has an eye that is not merely an optical instrument. She needed it, and used it, developed it probably, living with Emily Carr.

Anyway, she recognized greatness when she saw it. She is entitled to our gratitude and respect for cherishing it. Personally I am full of admiration and envy.

<div align="right">Kathleen Coburn</div>

LUCKY SEVEN

ABOUT 1917 my parents moved from Ontario to the west coast. For a time we journeyed from place to place while they looked for a spot to settle. Finally we landed in Victoria, in late summer. Though I was only seven years old my luck started then. Emily Carr, at that time nearly fifty, was giving lessons in painting and clay modelling. She happened to live just around the corner from us. Clay modelling was new to me but I was very interested in it, so my Mother arranged for me to take both the classes, daily from four to six.

You must know something of her studio; then when I tell you of Emily Carr, you will feel that you know her better. It was on Simcoe Street, just below Beacon Hill Park, on the second floor of a lovely old house which she had had built for herself. I loved the studio. Emily Carr was practical and the studio was a demonstration of her practical nature. There were two huge windows, one taking up most of one wall. On the other two walls were large paintings. Great hand-hooked rugs, her own handiwork, covered the floor. They carried out the Indian themes, so loved by her, in their colourful original designs. I have wondered often what became of her old studio

table. It resembled most the table in the pictures I have seen of our Lord's last supper. It was solid and large, only about three feet wide but long and heavy, with leather inlaid down the centre, strong, beautifully carved legs, and lovely dark old wood—truly a collector's item. For Miss Carr it was a studio table.

The room was large and high, and so were many of the canvases she worked on. To leave plenty of room for working, the three big easy chairs had ropes at each corner which ran through a pulley overhead and were tied to a small nail within easy reach. When a visitor or prospective buyer called, a chair was lowered, and there he sat, as she often said, "like a fly in a web and I the fat old spider!" Those who knew her well could tell quite easily in what esteem she held the visitor by the manner in which she returned the chair to its airy perch. If it was drawn up immediately the guest rose to his feet, he was a bore, a time-waster: "a dawdler," she would say, as the chair went up with a jerk! But if the chair was allowed to remain till the guest had departed, then it was understood that she was genuinely sorry to see him go. The new pupils, who had heard tales of the swinging chairs, would sit in high glee, waiting for callers important enough to be asked to stay till the lesson was over. They were much more interested in the lowering of the chair than in the lesson! At times like these Miss Carr would say, "No pupils today, I am afraid, only curious kittens, and we all know what happened to the old cat." Her easy sarcasm and gentle way of lightly poking fun at the children made those who were interested settle down right away.

8

At each end of the studio table were straight chairs and a stool with long legs for the younger pupils. They sat facing her at the long end of the array of partly painted pots, newly moulded things of all shapes, lumps of raw clay, boxes and tubes of paints. And always, in the middle, helping, sat the little monkey, Woo. Wherever Emily Carr worked, there was Woo and three of the little Belgian Griffons that she loved best. There were many more in the kennel at the end of the pretty garden. Ginger Pop and Coco, rough-coated little fellows, were her favourites. They were extremely jealous, always carrying on a half-friendly growling feud, but too well trained to do anything more about it. The third Griffon, a smooth-coated little female named Sugar Plum, was beautiful, but for that very reason a little less loved than the other two. "Beauty," Miss Carr would say, "reaps its own rewards, in whatever form it comes." Sugar Plum gloried in the affection the callers gave her, friends and strangers alike. Fickle? Well, we used to wonder, and it was amazing how many people we knew who were like her. We used to laugh about it. Miss Carr's sense of humour was wonderful; she loved to laugh.

The monkey, Woo, with her quick, active little brain and spirit of independence, was the most loved of the pets. Miss Carr had had her for years and had trained her when very young. Though most of her tricks were the common tricks of monkeys, they were always a great delight to those who saw them. Miss Carr lived alone for so long that the monkey came to resent anyone else who was about the place for long. It was a surprise and delight to us both when Woo made friends with

me readily. After a painting lesson, as I washed my hands and brushes, Woo would come and hold her little hands up, at the same time screwing her eyes tight, pretending she might get soap in them. When her hands were washed to her satisfaction, she would squeal suddenly, and dash away, soapy hands and all, pretending she had been soaped all over. This was because once, years before, when Miss Carr was washing her own head, Woo got too close, trying to help, and she really had got soaped. The fuss had been frightful, the monkey screechings indescribable! To stop them, and show she was sorry, Miss Carr had bestowed much candy on her. Now, when she saw anyone she trusted at the basin, she never failed to try for more candy!

It had been quite a problem to make Woo keep on the little dresses she always wore, but Emily Carr was as persistent as she was versatile and she made some of strong sail cloth. They were little coat dresses open down the back instead of the front. When the monkey was firmly in one, Miss Carr would hold Woo between her knees as she stitched the dress on, using a strong string. When the monkey, unable to get out of the dress, tired of pulling, Miss Carr would reward her by putting some of her favourite candy in the little pocket, which had had to be nearly welded on! In this way Woo gradually learned to respect the pocket, and after some time the dresses were made with buttons; the battle was won.

Woo's home was a cage with a sliding door that was almost never locked; her chain kept her in one spot. When night came, the monkey went down to her bed in the cellar;

Sugar Plum went out to her kennel. The cat, the parrot, and two dogs shared the studio at night; there was never a sound from them. If we had been out late, when we entered the studio the animals would be curled up sleeping. In the moonlight that streamed in the great window, they looked like the pictures lined up against the wall to dry, contented and happy in the night.

In a corner of the studio was the parrots' cage. They were huge birds: a green one that talked, and a white cock-atoo. Under their cage was the bed of Dolfie, the cat, a big bluey-grey Persian, in many ways more like a dog than a cat in his manner. This was her family of pets, and she loved them dearly. They were a great comfort and inspiration to her when things were hard. They were well trained, and though they actually were a great deal of work, it was work she loved. Very often, when she was lonely, it was a comfort for her to have this work to do.

The fireplace was beautiful, big and deep, but I never did see a real fire in it. "The greedy thing is a luxury which some day I may be able to afford," she would say, with a chuckle. She had, standing in front of it but using the same chimney, a little stove, open-fronted, a sort of miniature fireplace. It threw a fine heat and had a small shelf across each corner where the dogs and monkey sat in the cool evenings, as we worked on the pottery or rugs. A mere handful of fuel kept it going. On the mantel were some of the old pewter mugs and urns she loved so and had collected when she was studying in England and Europe, years before. She had some beautiful

pieces which she gave to friends the last years of her life, when she knew her time was not far away. I have several I prize highly, among them the little mug which stood on her studio table for years, then later on her dresser, holding the pencils she kept always handy.

Never was she morbid about death. She asked only that the work she had set herself be finished, at least to a point where some friend would not have a puzzle, trying to complete it. She thought always of the other person, of his feelings in these matters. She even made her own shroud, and had me lay it away in her bottom drawer. She had long been confined to her bed and she did not wish her sister, who was blind, to have extra trouble when the end came. When I had seen what she was up to, and had offered to do it for her, she said to me, "Run along, Child, I'll sew it myself; no need to sadden you as I know it would. Just think of me as an old tree whose leaves are about to fall, whose branches have supported its last nest of robins. I am quite happy, quite able to sew; go watch the swans in the park. Take my eyes and I'll see too." I went; but I couldn't see. No sadness in her tones, but the very matter-of-factness made it so final.

To return to the studio! In one corner, and beside the fire-place, were two couches. One was very tidy and neat, with a handsome afghan which Miss Carr had made, bit by bit. This was kept, with cushions in place, for the guests and callers. The other seemed generally to have a fur coat thrown over it, but at a word from Miss Carr, the coat would resolve itself into dogs, cat, monkey and white rat, and there would be a comfortable

old leather-covered couch that she called hers in spite of the fact that there seldom was room on it for her!

There were hundreds of pictures stacked about, all sizes, but if she was asked for a certain one, it was surprising how quickly Miss Carr could locate it. There were some water colours, but most of them were oils. Even on the ceilings of the little bedrooms upstairs in the attic were painted huge Indian birds of war. When her house was new, and she had first moved in, she had no "olds," she said, for her attic room, so she kept it apart, up its little winding stair, for her aches and loves, her sighs and joys. Her hopes were often born there, up beside the sky, among the leaves of the big maple tree she loved. She used it for her room, where as she said, "I pop in and out, like a cuckoo in a clock." Years later, in her apartment with her sister, after the *House of All Sorts* had been sold, she spoke often of the two big eagles she had painted there. They had lived with her for so long she sometimes felt they were still with her in the apartment. One of these little rooms was mine for years. She would say to me, as I went up to bed, "Sleep tight, Child, my birds will guard you as the robins did the babes in the wood."

PAINTING LESSONS

EMILY Carr was a true critic, and in many ways a harsh teacher. This may sound unfair; I do not mean it to be. I am writing this of the Emily Carr I knew for more than twenty-five years. She was always very fair. When asked for an opinion, she gave one.

When new pupils started, Miss Carr would say it was best that both she and they should know at the beginning how much Art they could absorb, how much they already had. If they lost interest after a scornful comment, as so often happened, she would suggest that they take music, or dancing as a possible career. But if, after a lesson, the work was good, or showed promise, or the effort put into it was sincere her few words of praise would inspire you to the greatest heights, set you right on top of the world.

When first I started painting I made two fatal mistakes. First, I painted what I saw as clearly as possible. This was very wrong. "Any fool can copy, Child, if he tries long enough; what you are to do is *create*, get the feeling of your subject and put *that* there." I had a bad time for a while. I would see a strip of beach, lovely sand, blue skies, green waters,

purple mountains in the distant haze, everything just right, and I was not to paint that, but rather the feeling I got, the strength of it!

Then, the other mistake I made was that I was always in a hurry. The scene might change, or a storm blow up; it did not take much to get me in a dither and on would go the colour, as it came from the tube. To say that Miss Carr considered this an outrage is to put it mildly! I soon knew that no painter ever uses any colour as it is, but adds a little of this, and some of that. Miss Carr's knowledge of colour was almost unbelievable, yet as soon as she found someone with a true talent all she knew was his for the asking. With her there was no jealous guarding of professional secrets as is so often the case.

After my modelling lesson was over, there was generally from fifteen minutes to half an hour left, before dinner, that I could use as I liked, to mould a figure or a dish. When it was done, she would criticize it. One day, as I was listening to a story she was telling at the end of a lesson, I made a little ash tray. It had three turtles climbing up the side, pushing with their back feet extended, the feet being the legs for the dish. With a sharp stick I drew the designs on the turtles' backs, representing the shells, and lines around their faces, making a glad one, a sad one, and a surprised one!

When the story was finished I handed her the dish. She reached for it and looked at it; then, laying it down, she took my hand in her two beautiful ones and said, "This little pig went to market, did it? No, not *this* little pig. For these little pigs, we must have some other place to go. Now let me see,

16

*This little pig went to Art school, and studied when she was
 home;*
 And this little pig loved Nature, animals made her glad;
This little pig loved beauty, on land, in the air, in her heart;
 And this little pig was loyal, would take anyone's part;
*And this little pig is my little pig, that I'll keep for my very
 own.*

Run now, time to wash and get home!"

My Mother had a lovely dinner ready, and I generally had
two servings, but that night I was full, full of a happy, holy
feeling that made my throat tight, so that it was hard to talk.
I was so unlike my usual self that I was sent to bed right after
dinner, with a dose of castor-oil!

At the Art lesson next day, when Miss Carr asked how I
was, I replied, "I am fine now; I loved the pigs but they made
me ill." She looked at me a minute, then said, "I know, they
upset me too and they *should* have been funny pigs."

The lessons varied a great deal. Much depended on how
Emily Carr felt herself, and quite naturally, on how I felt,
and responded. Shall I tell you of an average day and then of
a poor one?

As we proceeded to the spot chosen for that lesson, we
made a happy group: the monkey, three dogs, quite often
the parrot, Miss Carr and myself, loaded down as we always
were with the camp stools, easels, paper, bags of brushes and
pencils. Now I often wonder how we could concentrate as
we did, but after we had reached the spot chosen for the day,

and had arranged and settled ourselves, the animals seemed to know they were to have their fun quietly, and they did.

Miss Carr had one hard and fast rule; she always painted with her back to anyone who was around, and set her stool in such a fashion that strangers could not come up behind her to stare over her shoulder.

Almost the entire shore line was wonderful material, with great banks of rock, some nearly solid with trees. The browns and greens she loved so predominated, with the sea and the sky for all the harmony that was needed. I would be left to myself for an hour or so. The subject I chose, and the meaning I chose to stress, were left entirely to my whim of the morning. We would ignore each other as far as speaking, or deliberately distracting one another was concerned, but we both felt the moral support we each received from the other's company. Often, many years later, when all her painting had been ended, she would squeeze my hand as she lay so ill and say, "Baboo, I am so glad we had such splendid times together. Our days painting in the woods and on the shore, I live them over and over, and am happy again." I think she knew I did too.

After an hour or so, she would come over and stand beside me a while, to get the feel of what it was I was striving to express. Sometimes she would say, "Scrape, Child, scrape, scrape." That meant, "All wrong. Start over!" Or she might say, "Save that, start fresh." This meant generally that it was not all bad, it could be better. In the hope that the next one would be, she would have me start another so that the two pictures could be compared and criticized together. Before I

reached the point where the mistake had occurred, she was back and would stand a little behind me, sometimes for an hour or so. If I was doing right she would not say a word. Often, as she stood there, a colour, perhaps, would not come just right, and I would be about ready to give up, when she would lean over, and say, "Even good soup is no soup without a dash of salt," and add just a little of whatever it was my colour lacked. It was never what I thought it should be, and yet at once the desired tone would be there. She would say, "There, now you have it." I cannot explain, it sounds ordinary to tell it, but the lift it, or rather *she*, gave my ego, her free, easy manner, would make me sit for hours the next time, mixing and scraping, and mixing again, sure that the colour I wanted was there in the shadow.

Or again, I might have the shore line, and the sky would be beautiful, and I would concentrate so hard, do a very good job, and know it. Well, time would be going (it really does go quickly, when you are painting on something you like that is going well). So I would start the foreground, still so satisfied with the sky! She'd come over, take a look, and say, "Better take a walk, Child. See that tree over there? Well, take the monkey and the dogs and walk over slowly. While there introduce the shore to the sea, and *again* here, when you return." The tree might be a quarter of a mile away. Off I would go, with the pets. Not a cross word from her about the mess I was making of my canvas, nothing but, "Take a walk." In those days I thought she did this because the animals needed walking! It was some time before I realized why she did do it.

It did not happen often, of course, not unless a part was good. If all was bad, then, "Scrape, scrape." I hated the sound of these words. After the walk I'd look at my effort, and see the bad part, so bold and rough, then I would work at it with the vigour that had gone into the good part in the first place. After my walk, it was so plain that the good part had been made to suffer, and not as I had hoped that the good part had hidden over the "rough unbound edges," as Miss Carr called my bad places. "It is up to you, my Child," she would say. "You know best what you are capable of. If it is worthy of you, sign it." And again she would say, "Create, Child create, but do not copy, there are cameras for copies." So much credit was given your ability to think things out, that when you became used to her, you just naturally did.

Some Art teachers are always taking your brush, and dabbing at this and that, making pretty pictures out of a muddle, yet leaving the impression that you did it yourself, with no true criticism. She never did. Reasons are so very important to a student. With perspective, colour, shading, and so on to worry about, a correction goes by almost unnoticed, if a logical reason is not given for its having been made. "That tree is all wrong," some teachers would say, taking the brush and correcting the mistake. That is not appreciated by the sincere student. But when a tree does go wrong it is surprising how difficult it can become to correct it! The branches lose all supple grace and balance, all life goes out of them. You who paint will understand too well what I mean. Well, Emily Carr would come up; if it was really bad, she would set the canvas aside and on

another she would do the angry tree, making such a gay dunce
of it! "Meet this one, Baboo," she would say. "It is the cousin of
that one of yours, Child; scrape, scrape." And as if by magic,
my own tree would seem to grow and take life right under my
brush, yet what showed on my canvas was my own effort. "It
has to be, no two people work alike; we are not supposed to,"
she would say, as the gathering-up of our equipment began.
Yet how proud I would be, if ever, even once, I could do a small
one as she used to, with the same strength and deep feeling.

Perhaps I will omit the bad day. After all they were due
as much to my clumsy dabbing as to her moods, and to be
honest about them would make me seem a very silly person.
Her quick comments were always ready and would fit any
occasion. "Waste your time if you must, but I will not have you
waste mine," was a favourite with her, if a lesson had gone by
with no progress shown.

When a canvas was finished it was placed face to the wall
to dry out thoroughly, and not draw my interest as I started
the next. But how proud I would be, a day or so later, to enter
the studio late, and find her there, with my picture propped
up before her, the softest light in her eyes as she studied it.
When she became aware of my presence she would nearly
snap, "Well, what is it? What are you standing there for?"
But when I had finished what I had come for, and started
up my own little stair, "Good-night, little Baboo," she would
call softly, in the same tone of voice she used for the birds,
but she would be in her room, her door already half shut. I
knew that she did not want to chat, but there would be such a

happy, warm glow left inside me, it was good to tumble into bed and just think about her. And she used to think she had me scared of her!

I have said that she was casual about signing her pictures. "Sign only those worthy of you," she would say. "Set a standard, try to stick to it, and if one fails, set it aside for a time. That is one of the beauties of oil, it can be corrected, added to, any time. Sign only those worthy of you." It is such a straightforward, simple standard to go by, yet it is surprising how hard it makes you work. There is a great satisfaction in the final touch you give to a painting, as you sign it. Yet so many, some of them important people, do not seem to understand *why* she did not sign all of hers. Some are very plainly not finished, though they may have been started years ago. Others just did not reach the standard she had set herself.

Once, years ago, when looking at one of my paintings after a long hard lesson, she sighed as she said to me, "Baboo, you have a softness in your work which I am not able to equal any more, but, my Child, life is *not* soft—just the dawns, and the twilights, and they are often racked with pain. But you are young, Child; paint and paint, and then paint." She was sure the years would add their own touch to my work, as it had to hers.

Many of her sayings have stayed with me through the years, with the memory of the gleam in her eyes as she said them. It is a blessing I shall ever be grateful for. Her standards—what a goal to strive for!

No sham. No fraud. Or no signature.

MOULDING CLAY, AND HEARTS

YOU must know someone with lovely hands. You will understand then the pleasure that can be derived from watching such hands perform even a simple task. Emily Carr had lovely hands. Even as a youngster it was hard for me to concentrate on the work before me. I would sit and watch those strong, beautiful fingers, as they moulded and shaped the clay into all manner of bowls, vases, menu-holders, ash-trays, door-knobs, buttons, brooches and lamp bases. There seemed to be no limit to the number she thought up. They took shape and grew in her clever fingers. In the cellar, where she did all her own firing, she had had a real kiln built. She had become quite expert at glazing in many different ways.

By 1924 Miss Carr had become very well known for her lovely pottery with the bright Indian designs. I was then about fourteen and had studied with her for seven years, when she asked me to live with her. I was still to continue with my schooling and Art lessons, but I could help her with the pottery orders which were coming in fast. I was thrilled, of course. I was with her most of the time, anyway. I knew her very well and loved her dearly.

23

One day, about six months after this, she called on my Mother and asked if she could adopt me. I had a sister and a brother, and she said she thought "things could be divided up a little better." My Mother was a wonderful person. She thanked Miss Carr and said that she knew how happy I was there, and that I could certainly continue to live where I was receiving such wonderful care, but I was to remain Carol Williams. Never at any time was I consulted about it by either of them. I never thought about it at the time; now it seems right that I wasn't.

Until that day Miss Carr had always been Miss Carr to me. That evening she said quietly, as we sat with the animals, "Child, I have two big wants. One is for a daughter of my own. The other is for a baboon. You will always be my own daughter, in my heart at least, but I am sorry you will not be my legal one. As you know, I am Mom to my dogs and my monkey, so may I be Mom to you, too?" She was saying it in a way she hoped would be half funny, adding the bit about the baboon! "So," she went on, "I will call you Baboo; you can be to all, for ever my Baboo, and I will be Mom to you." She was, ever after.

So that my own Mother's feelings would not be hurt in any way, she went back and explained to her that the name "Mother" was not infringed on in any way. She said she hoped some day I would have a mother-in-law, but she was to be from that time on, my mother-in-love. The very term mother-in-love seems to me to tell you more about this sweet little old lady than I ever could. A heart has to be very soft, a mind very

agile and sweet, for terms that sound like that. Then she ran her hand over my head, and went on her way, but my hair tingled; there were kisses in her fingertips.

Nearly every morning during those first years, we walked in Beacon Hill Park. The flowers there were lovely, but they seemed so much more so when I was there with her. She had a deep love for them, her words of admiration coming almost unconsciously as she inspected each bed of blooms to see how many more colours and buds there were than on the evening before.

The birds were a great joy to her also. Many were known to her by name, and would fly down to her when called, though they were the wild birds of the park. They had been tamed and named by her at various times, as she had worked her magic on them! Ego, Perky, Saucy, Yappy, Pretty, Chit, would all fly down from the trees as she called them. She would soon be surrounded; her pockets were always full of the choice things she knew they loved best, and had saved for them. They had grown to know and trust her. That it was not all tummy love was quite evident. I would be sitting off to one side, with my few crumbs, but only one or two of the braver ones ever came near me. Her love and understanding of the birds had developed in England years before, when she had been ill for months and had become very fond of the birds of which she had made pets. It was beautiful to hear her talking to them; it made you hope that when you were a mother some day, your own baby would hear the same tones in your voice. They were there in my Mother's the day I was married, when she called

me to get up. All she said was, "Come on, little lady, time to get up." Nothing as far as words went, but the same tones were there.

The raw lumps of clay were moulded into beautiful things, with the strength, the skill, and the love in those lovely hands. In the same manner wild animals, domestic pets, and some lucky people, who came in close contact with her, were loved and moulded, by the very depth of her understanding, genuine sympathy, and the Artist in her soul, that just naturally strove to put all it came in contact with in harmony.

The pottery pieces and beautiful pictures, the books that have the power to hold you, are here for the world to see, to admire, and be grateful for. But if there were only some way to measure the good and comfort that she poured on lonely, sick, or wanting people and animals!

GATHERING THE CLAY

MANY people along Oak Bay, James Bay, and in Beacon Hill Park had labelled this wonderful person queer mostly because they did not know, or understand, her.

She had many ideas, most of them labour-saving, that the public did not understand, but as they were great time-savers, they worked for her very well. As far back as 1925 she had the idea that a baby carriage would be just the thing for bringing home groceries. So we got a large deep one, painted it brown, and went shopping. Such a howl you never did hear! A crowd followed along from store to store, jeering. They made all sorts of remarks, mostly unkind, some rude, about "old women who could find no better uses for baby carriages," and the suggestions they made were quite vile. She ignored them completely and went her way. Woo, the monkey, tied to the handle, sometimes ran alongside, sometimes jumped on the cover to ride. Always we had the three little dogs following. After all, with so much painting going on, they had to get out for their exercise whenever we went. I would be tagging along, generally pushing the carriage, always with her. Once she turned to me and said, "Child, there is no need for you to

27

be laughed at. You go along by yourself across the street; I'll pretend not to know you and we will make a game of it." This was to give me an easy "out." As if I would take it! I could have shouted at them, I was so angry, till, seeing my concern, she said, "Think, Child. It is they who should be pitied; they may have no real interest in life, no pets of their own." So we would continue on our way, chatting, ignoring them completely, and she would pause along the way to admire the trees, explain the colouring of a new flower to me, or pet a stray dog. Yet it was *they* who said that *she* was queer. Now, in the '50s, many shoppers in the big grocery stores have their own little grocery carts.

We used the same carriage when we were gathering the clay used for the modelling classes and pottery. In some cities, where there are large Art centres, the clay may be purchased, already processed, by the pound. But in Victoria, over thirty years ago, there was very little or no call for clay, so the ever-active and busy little artist gathered her own.

On the long walks we took each day, we kept our eyes open for new buildings about to be erected. As soon as we found one, with the digging about to start, we would pass that way daily, till the workers had dug their way down to where, if there was to be any, the true clay should be. Modelling clay has to be of a certain consistency. It is very hard to find, and is difficult to determine when you do find it, as all clay looks and feels very similar. The poor workmen! They were quite sure we were both mad. The new cellar might be from ten to thirty feet deep. I would go down, gather up a lump of

the moist clay, and take it to Miss Carr, who would carefully feel it between her fingers. If it was promising, she would then bite off a small piece and grind it between her teeth. If it gritted, or squeaked, it was not what we were looking for, but *if* it stayed gummy, it was! The men would watch in wonder; they never did make head or tail of it. If it was gummy, Miss Carr would stay there, and I would rush off for the wash boiler and baby carriage. We had also a small pail, an old potato pot, and a length of rope. If, when I returned, the clay already taken out of the hole was still clean, our task was simple. But if, as so often happened, they had dug below it again, and fresh gravel or sand was covering it, then down the hole I would go again, to scrape the clean clay from the sides of the hole. When the pail and potato pot were full, Miss Carr would pull them up and dump them into the boiler in the carriage. Have you any idea, I wonder, how heavy clay is? The tub, when full, weighed over three hundred pounds. Before I joined her, she used to go and gather her clay alone in smaller quantitiés, but with the same procedure each time. At that time she was the only person in the district interested in the clay for modelling. Till then the clay for studios had come from England. But, as Miss Carr said, her love for the West included it all, even the earth.

When the boiler was full, I would pull, like a horse, on the rope which we had tied to the front, and she would push. The dogs and monkey loved it; as the load was heavy we made many stops, which gave them lots of time to explore along the way. They never wasted a minute.

When we reached home with our load, it was dumped by degrees into tubs used only for the purpose, and covered with water, to weather. The days of processing were many, and were called "weathering the clay." I often wondered, when the pots were finally made, and fired, and painted, how they could sell at any profit, at a price of only a quarter for the small ones!

Each gathering of the clay, after we had washed and weathered it to the desired consistency, would make from three to five hundred pots, or what have you, depending on the size.

The monkey, as well as the men, was quite sure Miss Carr was withholding something that, if explained, would make sense out of the business of tasting *mud*. Little Woo would watch very carefully and would pick up the exact piece that I had given Miss Carr, after she had dropped it. She would gingerly bite off a small piece, only to spit it out immediately, and jump up and down, in a rage at having been fooled again.

Miss Carr, then past sixty, told me a little story about the rope which we used to pull the clay. I loved it and, if there is any of the out-of-doors in your soul, you will too. The little, woven, soft piece of rope had been given her years before, when she used to ride her pony with a Western saddle. It was the lasso which was kept tied to her saddle and used to tie up the pony on the occasions when, far out in the country, she would stop to sketch!

They were wonderful days and Miss Carr a wonderful woman. It is a shame she had to work so hard, when her beautiful pictures, now so valuable, were then stacked about

unsold. They were completely ignored by all but a few, who did very little about them.

Emily Carr did not mind the work; she loved the cool, clean clay, and working with it. She hated only the rush of supply and demand, the mercenary end of it. The worry of the kiln was very great, the labour too much for one person. It was a dangerous and tiresome job, and that is why she did it herself.

The clay on the west coast is wonderful to work with. I have no way of knowing, but I hope some is still being used and that all Miss Carr's work along these lines will live on and continue to give satisfaction to busy, clever fingers.

In those days, *I*, like the monkey, thought the business of tasting the clay was going too far. Now I realize that it was the only fast, sure way to ascertain that it was the type we needed.

Today, when I find a new hole going down, people stare at me in wonder because, you see, I too taste the earth.

INDIAN POTTERY

EACH of our trips into the country was an event, never to be forgotten. Some were sketching trips only, others were wonderful treasure hunts, when every nook and rock was explored. Miss Carr used the natural little sea shells and rock formations for her models in many of the small pottery pieces. The Indians, together with the beautiful country, with its sea and mountains, wove themselves into the pattern that formed our day. We would have the monkey with us, the dogs of course, generally a parrot and the cat, plus the sketching material, stools, and food, because we stayed all day, sometimes ending up in a tent or, if there was one handy, a cabin. We always had such an assorted, bulky load! Very often our cabin would be one shared with an Indian. Emily Carr understood the Indians fully and loved them. They called her Klee Wyck, which meant Laughing One. This will, in itself, explain the high esteem in which they held her. It is not possible to fool the Indians for long, certainly not for over fifty years.

The main reason, I think, for her high regard for Indians was their direct way of expressing themselves, without sham, and in very few words. It was apparent at once whether they

liked you or not. Without rudeness, they ignored those they did not take to. Their great love for, and understanding of, animals was in their favour, of course. When someone began, "Why I knew an Indian once who . . .", Miss Carr always said, "I'd rather not hear it; there are a few bad apples in every barrel, whether they be Dutch, French, _____, or Indian." Always she would add the brand of the person speaking. This little strategy on her part paid off many times. Like the Indians, Miss Carr could express herself in very few words, in many cases directly to the point.

Many many times, after a chat with her, maybe an hour or a year later, something she had said would come back to me, and the real meaning would be so clear that I'd wonder how I had missed it in the first place. Emily Carr was a wonderful person to talk to. She was not good at making small talk, but about anything that mattered, it was a treat to spend an hour talking with her. As well as being very entertaining she was an attentive and sympathetic listener.

All through the years the birds have played a big part in history. I loved the interesting stories Miss Carr told me about them. It seemed to me, at first, that she was explaining her great love for them, but this was not the case. When she decided to use the Indian bird designs as the motifs for her pottery, it was with a partly guilty conscience that she did so. The Indians had, all through the years, kept their decorative work pure and simple, yet decisive. When she decided to follow their lead along these lines, she felt she could proceed with an easy mind. The large birds of war were her favourites, but any

bird was an acceptable subject. When Miss Carr sat, brush in hand, the birds seemed to grow and come to life before her. She combined the Indian elements of vitality and strong abruptness, and the finished products were very attractive.

It was the Indians themselves that Miss Carr was afraid of betraying, not the people who purchased the pottery. When I admired her pottery with enthusiasm, she would say quietly, "They are too new yet, give them *time*. One finds out one's possessions in time, as one finds out one's companions." Then she would smile. There is no way of describing her smiles, as the sunrise cannot be described. It was never the same but always beautiful.

This combining of two loves, Indians and clay, was to her serious business. That she loved it was evident in the finished product.

The stories Miss Carr told of the old Egyptians and their birds, which had a sacred significance, and the ancient Chinese whose birds were social emblems, were many and varied. In the middle ages the knights used birds on their armour as symbols of estate. She had all the facts and, as told by her, it was a story I never tired of hearing.

There is something very appealing about Miss Carr's bird designs whether they were the strong crude Indian birds or the soft grey doves she did so beautifully. The realistic and conventional designs of the peacock, all brilliance, and the parrot and pheasant, with their richness and vitality, appealed to people in any mood. They seemed to build up, and store, all the love and thought God had put into them in the first place.

35

Miss Carr was upset about the name given to her pottery, by the public. They seemed naturally to call it her "Indian Pottery." This was in itself a fake, as the Indians themselves did not have pottery of any kind. If by chance they did have some, it was certainly not decorated with their designs. These were kept clean and whole, for totems and canoes.

The modern "potters" on the Coast have copied Miss Carr's interpretations of the Indian designs, without understanding, with no love or feeling, and now there is a hodge-podge of pottery that attracts only the tourist trade. The old Indians are dying out. Instead of memorials to Emily Carr, which she would shrug at, I am sure, figuring mentally how many children longing for Art the cost could have helped, it is a pity a Pottery Centre could not be started for those who love to model, with an instructor well trained in Indian designs. It is no wonder Emily Carr loved these designs, so simple, but so very beautiful.

I have given them time. Twenty-eight years of it. She was right again, as she said, "One finds out one's possessions in time, as one finds out one's companions."

SKETCHING TRIPS

HAVE you heard your friends say, when they were getting ready to move, or for holidays, that their dogs became fussed and uneasy, at sight of the open cases and trunks? I wonder then if you can imagine the to-do at Emily Carr's home, when her cases appeared, as she prepared for a sketching trip? The monkey would be as coy as a ballerina. She would smile and flirt, as she pretended to be very busy in a corner, but as soon as backs were turned, into the open cases would go her own little treasures. These included peel from discarded fruit, insoles from any shoes that she came in contact with and it is amazing how often the door key, or any key, disappeared into the case. Often, at the last minute, as we were about to leave, all the bundles and baggage nicely and securely tied, the search for the key would start, as the taxi waited! "You had it." "It was there." "Surely you did *not* put it down!" "If heads were not . . ." Everything had to be unpacked and carefully shaken out. Have you ever had the need to find an article as small as a key while a taxi, with a driver who was not fond of animals, waited? Then, as likely as not, we would remember that it was not in that one anyway, but in the small box with

the nailed-down lid! The little dogs would watch Miss Carr's every move, and each other, while the parrot never stopped talking, afraid, I think, that he might be overlooked in the general mix-up. I was just as much nuisance as any of them, I guess.

"Where would you like to go, Baboo?" Miss Carr would ask. We had discussed it several times, and were undecided which of two places we would visit. They were nearly all new to me but she had been to all of them several times in the past, in some cases many years before. Then it had been the big English Bobtails that had gone with her; they were so big that often only one could go at a time, but the Indians liked her big dogs then, just as they liked her little pug-faced Griffons now. They would often gather around her, the old as well as the young, and go into gales of laughter at the little dogs' clown-like expressions.

When the Bobbies had accompanied her, they would sit calmly as she painted, giving her moral support, keeping her from loneliness or the dread that the wild, deserted villages strove to create. They had been deserted so long that the growth, lush and greedy, now pushed into the places where the clearings had been, up through the boards, in the cracks in the big totems themselves.

It was the glowing, vivid stories which she told me, her eyes shining with her own memories of them, that had built the great urge in me to see them too. Her painted pictures are satisfying, her books are alive, but her stories, as she told them, brought the five senses into play and fully satisfied them. I

lived them too, and laughed and cried with the little girl that was the heroine of them. As the story progressed, the girl was there before me, and it was with her I roamed the hillsides, sketching, gathering the flowers to take home and paint later. When the storms came up, four feet would be wet, two heads would be tired from the wandering both had enjoyed. When "good-nights" were said, there beside her studio fire where Miss Carr had told the stories, I would sleep quite as soundly, with dreams as sweet, as the little girl of the tale must have slept years before.

The sea had always been a love of mine, so it was a trip by boat I chose. The year before I met Miss Carr, I had become acquainted with the Indians at Westholme. Partly because I rode a great deal and was always out in the open, I had frequently been in contact with them and knew some very well. They had been very good to me, showing me the best trails, letting me ride their choice ponies. They were real friends. When Miss Carr knew this she was very pleased. The Indians had come to mean much to her, and for her it was very sad that so few people on the Island knew them well.

We carefully counted the days that we would be away, and arranged the food for ourselves and the animals, including extra biscuits for the Indian dogs. They loved them. We had stacks of sketching material, several changes of clothes, a roll of bedding, cooking pots, two plates, two spoons!

On our first trip, I packed a clock, a calendar, pillows, all the things I thought she had missed. I wanted to impress Miss Carr with my thoroughness. "Why?" That was all

39

she said when she saw my little pile. I didn't know why! Miss Carr went on, "The Indians, Baboo, eat when they are hungry; they sleep when they are tired. The exact time and date mean nothing to them at all. For the next five days we will be Indians."

When we arrived at a destination, arrangements had to be made when we were to be picked up again, as in most cases there was no way to contact our means of transportation. Miss Carr had found out on her many past experiences that the less taken, the better, and made for a much happier journey. The Indians always travel light, and they have a quiet respect for all who do! This is especially true when transportation problems are completely in their hands, as ours were. The animals they understood and accepted without a word; their own pets went with them always. Our trip to Alaska had been by steamer, and was therefore a very formal trip compared to the one we were now planning. When we were ready the pile of luggage left the impression we had forgotten our plan to travel light. There were two boxes of food, "for the two- and the four-footed hungers," as Miss Carr would say with her little grin. The animals travelled in boxes too, one for the dogs and one for Woo and the cat. Though the parrot had a basket, he was seldom closed in and generally rode on the shoulders of one of us. The clothes, mosquito oil, and so on, were in another basket; then all the sketching material, with the camp stools tied on, made a very bulky package. We carried quite a lot, even when we kept it down to essentials.

We had two taxis to carry our load to Oak Bay, where

our Indian friend was to meet us with his motor launch at a given time. When we arrived at Oak Bay, I looked up and down the beach. No one was in sight. My insides went cold; the trip meant such a lot to me. "Come along, Child, do not dawdle all day." It was Miss Carr, calmly and busily unloading the taxis, quite unconcerned, as if she had fully expected to find the beach deserted! But I had been right there when the arrangements had been made, and we were then more than half an hour late (due to the key!). It seemed to me our Indian had given up and gone. The cabs were unloaded at last, and moved away, leaving us sitting on our pile of boxes. Miss Carr busied herself almost at once. She let the animals out of their little prisons, untied the stools, arranged some drawing paper on her board, and "Well?" was all she said. She then calmly started to draw and sketch the scene before her, quite as if it was the one place she wanted most to do! I walked up the beach and back. The animals were all playing about, the monkey having a wonderful time with all the boxes, which were much too well tied for her little fingers to damage. The animals were quite as relaxed and unconcerned, and as happy just to be there, as Miss Carr herself.

We were there for three hours before that man came, with not one word about why he was late, with no explanation whatever. When I questioned Miss Carr about it later, she said the Indians were never on time for anything. Once you know them, she said, you always allow from two to three hours, *always*; it was the same at the schools, the churches—time just wasn't. The only rush they ever made was a slow one, when

41

a certain boat was due, then, with an eye on the sun, they did seem to make an effort.

Our Indian friend had arrived in his gas boat. Tied behind was a nicely carved canoe in which he came ashore. He used his boats for fishing, when the need for money was urgent, but generally he and his family just loafed about, up and down the coast, enjoying nature. The cabin on the boat was surprisingly clean, but the Indians are like that; either they are clean, or they aren't.

He came ashore in the canoe and proceeded to load our things into it. There was no haste at all! The job had to be done, so he did it. As he had to make several trips, some boxes and Emily Carr went in the first load. When they reached the launch, another figure came into view and helped with the unloading and steadying of the canoe. This turned out to be his son, who was a big, well-made lad, strong and lazy, who could do a man-sized job when the spirit moved him; but "his spirit is lazy too," Miss Carr said with her chuckle.

I went out on the third and last trip, tucked in among the last of the boxes. It was noon before we got away. We sailed up the west side of the Island without stopping till the sun was about to set. We sat on the starboard side of the boat, watching the coast and the gulls and the funny little shore birds that play games with all passing boats. Sometimes we were a half mile or so from shore, and again only a few feet. It was surprising to me how that Indian knew all the danger spots, out there, along the wild shore line which looked all alike. We seemed to be in deep water, but he would suddenly

turn sharply at right angles, go around something that wasn't
there, and then continue on again. Miss Carr said he did this to
avoid the jagged points of rock jutting up almost to the surface
of the water. They were continuations of the mountains, she
said, that ran along under the ocean. The rocky little islands
that peppered the coastal waters were the high mountain
peaks, from under the sea. I had never given the little islands
a thought! Now they seemed so much more interesting. We
giggled and joked about it, to help pass the time. How silly it
must have sounded: "Sorry we are late—but our boat ran into
a mountain!" But it didn't. We made camp that night about
sixty miles north of Victoria, in a little bay known to Jim, our
Indian guide. We put in the canoe only what was needed for
the night and morning, plus the animals, and we were ashore
in only two trips. Our tent was put up, boughs were piled for
beds, and rocks for the fire. Then our friends went back to
their boat. They very seldom spent the night ashore, when on
a trip, if the boat was at all handy and sheltered.

After we were settled, and the animals had lost interest
in the empty cans, so that we could bury them, we sat beside
the lantern and took turns reading aloud the poetry she had
brought. The sound of the surf nearby, and the night birds'
songs, united to lull us to sleep, in spite of the fact that we had
decided to stay awake and watch the moon cloak the mountain
behind us with light.

We woke early, to the monkey's chatter. It was a beautiful
day, the kind described in detail in the travel folders. The gulls
were wheeling and calling overhead, great clouds of them.

43

"Our welcoming committee," Miss Carr said, and none could have pleased her better.

She got her sketching materials out as I prepared the eight breakfasts for the busy little group. The pets were very good but they would watch intently and keep count, I am sure, as bits of this and that went into each dish. After things were cleaned away and the fire put out, I got my stool and sketching pad. But out there, in the great vastness of it all, I could only look and look. Have you ever noticed a horse, when it stares at something? It will stare and stare, then look away, for several seconds; after several serious blinks, it will turn and stare again. It is almost as if it wants to give what it has already seen time to settle, be digested and stored away there ready to be called on later. That is how I felt, trying to fill my eyes full and pack everything in.

"What is wrong, Baboo?" Miss Carr said, suddenly. "Can't you pick something out? Do not worry, for now. Match those lovely soft colours, mix them carefully to match as nearly as you can. The memories will lock themselves away in your heart, and will return to you some day when your world seems dull and drab, when you have forgotten for a time such colours existed."

And do you know they did just that, twenty-six years later, in a hospital room. I was very ill, and the nurses had done all they could for me. Suddenly I saw the little cracks in the plaster, overhead and high on the wall, and it came to me that they formed the outline of the mountains that had towered above us then; and the lovely soft colours seemed to fill in

of their own accord. Even the warm glow was reflected. It made me warm and happy inside, as I remembered her and what she had said so calmly and kindly many years before, and I was able to sleep. Next day I was much better, and the nurses wondered why! Could I tell them of the small cracks in the plaster?

There have been many times in my life when the things Miss Carr said to me returned, steady and strong, like her presence beside me.

But to get back to our trip. It was noon before our Indian friends stirred. There had been no sign of life on the boat all morning. When, I wondered, would we continue our journey? With Miss Carr still sketching, it was no time to ask. That is one reason I gave up painting after I was married. When a sketch or painting is started, dinner time, door bells, phone calls, even horses wanting exercise, mean absolutely nothing. My whole interest would be in the particular shade I was mixing and in the final effect I was after. This cannot be explained to a hungry man. Though just a child then, I had done enough myself to clearly understand her attitude, and I deeply respected it.

The Indians must have eaten on their boat. Just at noon they came ashore, and very casually started loading our things for the next part of the journey. The partly finished picture on Miss Carr's canvas meant nothing at all to them. They were ready. The tide and the wind suited their purpose, so our things were gathered up, even as we used them, and we were off before we had time to think. Miss Carr often said

the Indians were ruled by the tides and the seasons. She knew and understood them so well. Even ignorance, seemingly gross carelessness, is forgivable when completely understood. Her patience with all animals, as well as the Indians, was childlike in its graciousness; but when with adults, whose thinking ability was taken for granted, she wasted little or no patience whatever!

Soon we were aboard again, boxes, animals, little tent, all securely packed away. We settled our backs against the cabin and again watched the beautiful, ever-changing shore line. It was quite deserted except for an occasional wild animal, grazing at the water's edge, or a few Indian families going peacefully about their business. This second trip lasted only a few hours before we reached the spot, carefully chosen ahead of time, for our camp. The lush growth and huge trees seemed to dwarf us to nothingness. The ferns and nettles were too big for their stems, which glowed pale and small under their immense leaves. Have you ever noticed that when some stout people are standing, their ankles seem too slender to support them? "That will do, Baboo!" Miss Carr replied, when I pointed the ferns and nettles out to her, adding my little simile. She *was* quite stout, and her slender delicate little ankles were her only vanity. "I will not be likened to a nettle to prove your point," she said, with her merry grin. It was when she was like this that she seemed much younger to me, than I was myself.

The scenery was lovely, but set back a little was the burial ground of one of the Indian tribes. Here the trees had been used, in many cases, to support the poorly-made coffins, which

were like huge birds' nests, partly wrecked by the storms. This, as far as our painting went, was far beyond me; I had no urge to paint in their cemetery. I stayed with the sea and the mountains. They were ever-changing, always strong, though sometimes, with the sunlight falling over them, tender and gentle. I loved the scene and worked like mad, but when I looked, after hours of *hard* work, and saw the weak little thing on my paper—! *How*, I wondered, *did* you paint *strength?*

On the shore where we landed next was an old deserted one-room building. The door was carefully padlocked, but one wall was partly out. Our Indian friends again helped till we were moved in. The animals were turned loose, except Woo who was chained to a rafter. She soon had all the wild birds chased out of our new home! The Indians supplied us with wood, pointed out the location of the spring and filled our water pail at it. Then, after sitting smoking on the beach an hour or so, they left, saying that on the fifth day they would return.

The barking of the dogs a little later warned us that something or someone was approaching. We followed them down to the beach to investigate. It was Joe, the Indian boy, tying up their canoe! He grinned a sheepish grin, backed off into the sea, pointed at the canoe, said, "We think you might like," then turned and swam out to the launch, a quarter of a mile away. It was very good of them to lend us the canoe, for it meant they both had to swim to and from shore till they located another! But it was wonderful for us, for we were able to see so much more of the coast and its beaches. In many places the forests

47

came close to the shore and was too dense to walk through on foot. These two, who half an hour before had left without even a "good-bye," who, in spite of their help, seemed almost ungracious, were, after all, most liberal.

They had also placed in the canoe two paddles and some fishing tackle. This was something we had completely overlooked, but it proved very useful and even provided sport the monkey thoroughly enjoyed. You know the alive, expectant look on a child's face, as he watches you hold a Jack-in-the-box, not quite knowing just when you will spring the lid? Well, that describes Woo. She would sit so still, never taking her eyes from the line, absent-mindedly pushing dogs and flies away. Then her wild glee, when the line jerked and we would land a squirming fish as close to her as possible!

The time passed quickly. Every day was about the same. We travelled miles together up and down the coast, in close to the shore, often landing where it was open enough and walking far inland. There were, at times, spots so beautiful that we had to paddle far out from shore to focus properly, if the shoreline was the subject of that particular day.

The trees grew close to the shore where a big rock jutted out. We had drawn our boat up on this rock. It slanted smoothly but steeply into the water. As the stone's surface was dry each day when the tide was out, it was never slippery to walk on, in spite of the slant. When the tide was coming in it was a wonderful place to bathe; the incoming tide would push the shallow, warmed water before it, and we would slip into it, with great bars of soap. By the time we were well

lathered, the tide would be high enough to rinse us with fresh, cool water.

The dragon flies would skim along the water's surface, as if daring us to stay another second; and, while we were in the water, the birds would venture out of the sheltering trees to gather the crumbs Miss Carr had scattered for them. Woo, the dogs, and the cat would all gather on the rock at the water's edge, scolding, then pleading for us to come out. Often, in the evening, we would see deer and many of the mountain animals come to the shore to drink. They would watch us long and intently, and often I was able to get pictures of them with a camera. But if a deer, a bear, or a moose was drinking, from the spot Miss Carr was painting, she never put it in the picture!

We painted, and sketched, and read to each other. Sometimes we took turns telling stories, making them up as we went along. If one of us suddenly stopped, the other continued for several minutes. We had such fun together, relaxed, happy, a woman of fifty-three and a girl of fifteen, and all the animals.

It seemed right to us that the day we were to return was dull with threatened rain. The rain leaked every little while, not able to stay up in the flimsy little cloud that it was trying to hide in, and a few spatters would fall. "You see, Baboo," Miss Carr said, "we are intruders no longer, we have been accepted. Nature and her beasts, and her green growing treasures weep that we leave."

She made me almost glad that it rained a little. She did it on purpose and in such a way that I was extra glad to have

49

been there. It made leaving like putting a lid on a box of treasures, something to be taken with us, kept always, enjoyed at our leisure.

When we were unpacking at her home several days later we found, pushed far down in the corner of the boxes among the soiled clothing and linen, the head of one of the fish we had eaten, several sea shells, a lid from one of the cans (which we thought had been carefully buried) and the skin from an old grapefruit! And you think monkeys are nice tidy little fellows, that mind their own business? But we did laugh.

About 1930, when the heart pains began to come and she tired very easily, Emily Carr thought out another plan to make the sketching trips possible. Her friends, who knew how much depended on her trips out into the woods, thought her a genius. Those who did not know her, did not understand her, were quick to criticize.

This all happened long before car trailers were thick on the roads. Any there were, were light little two-wheel affairs. Miss Carr got a truck body and had it fitted up with neat built-in cupboards, shelves, and furniture. It had good strong wheels, though it was a little rough outside. She arranged for a man to tow her with his truck into the woods when she wanted to go. There she would sketch or rest, as her tiring heart demanded. She would stay sometimes a week at a time, or many weeks, depending on the weather. I enjoyed many of these trips with her when, after my marriage, I went West to visit with her. But even in her caravan she could not be free of the unkindly, curious public, who would poke about,

though she would have welcomed them graciously, had they given her the chance.

Miss Carr's friends went to visit her on Sundays and had many lovely picnics there, with the little animal family, out under the trees. On these occasions, Miss Carr was always so relaxed and amusing as she related the meetings of her little pets with the wild animals. There were smiles and chuckles everywhere; her descriptions were so accurate and colourful, it was almost as if the incident were taking place before them. Imagine, then, the gross ignorance the strangers would show, wandering about as close as they dared, listening and staring. There was never anything out of the way going on. I would get angry clear through, but Miss Carr never let me show it. "Don't give them the satisfaction, Child," she would say. "Poor things, they may have no place to go, no real interests; I suppose we should be proud. But just ignore them, be glad you are able to enjoy the woods and the animals." I would have to grin, as I wondered what *their* reactions would be, if they knew *her* reasons for letting them be?

Again you see, the advice given to me by Miss Carr was reasonable, quiet, short, and to the point. Yet when she refers to herself in her books, have you noticed that she leaves the impression that she thinks of herself as a devil to deal with? This is I think, because she was a severe critic of herself always, of her painting and writing. She was the last to give credit to any of her own hard work.

Miss Carr's paintings, years ago when they were very new, puzzled many people. They had become accustomed to the

copies of land and sea done by many artists of the district. Her large canvases, with their vivid colouring, great feelings of strength, space, loneliness, age, youth, anything at all that she wanted to express, were very different and not everyone was capable of understanding them. So, at once, her paintings were labelled queer.

She painted what it was that she felt as she gazed at the subject before her, and with her great imagination at work on her canvas, trees came almost alive. She could give such dignity to an old grey stump that she made it seem almost holy. Beside it would be the gayest, most devilish little tree, carrying on with another little tree. In this way she would portray their great wisdom and extreme youth, with no apparent effort at all.

Some of Emily Carr's best paintings are trees or groups of them, as seen by her in the great forests of our Canadian West. Her love for the West is there on the canvas for you to see. A mother cat, washing a kitten, holding it firmly but at the same time accomplishing the job thoroughly and gently, that was Emily Carr, at work on a canvas! Gentle, loving strength is hard to portray on canvas; it is even hard for me to put words around.

PULLING DAISIES: HE WILL, HE WON'T

LAVISH though her use of colour and descriptive words may have been, when it came to dress Emily Carr was simplicity itself. She insisted on fresh clothes every day, but they were as plain as possible; her dresses were almost like shortened nightgowns. As she said, they were the easiest to get into, also they were less showy on her plump little body. Once you knew her, you never gave a thought to her weight, mostly, I think, because she was the first to poke fun at herself. After only a minute or two with her, you were quite unaware of it, so completely engrossed would you become with her eyes, her hands, and her manner, which, when she was interested or entertaining, was almost a magnetism. Even differences in age were not apparent; people of both sexes and all ages felt the magnetism when they were with her, that is if they had a real reason for being there. She could smell out a faker every time, and for these she had no patience or time, and very few words.

For several years my family came back for the summer months to their summer home in the Haliburton area, but returned to the Pacific coast soon after the first frosts came. My close association with Emily Carr lived through all the

separations; her letters were so alive and chatty, that though I was only a child I kept most of them. Miss Carr was not famous then; she was poor, she worked hard, and at times was openly made fun of.

About that time there was some talk of my going to Europe, to continue with my painting. It was to be for a four-year period, and Miss Carr was to choose my teachers. I was not overly anxious; I hated the thought of being so far away from everyone I knew; also on one of the summer trips East, I had fallen in love, and nothing else seemed important. My Mother, when I told her, pointed out that I had just turned seventeen. She suggested that we go West again, for the season at least. If, at the end of that time, I still wanted to be married, whenever it was, she would return East with me for the, to me, great event. She was so very fair always. Miss Carr asked only, "Child, could, or would you keep house, and paint?" Then, I thought I could! Emily Carr and I talked it over at length. The boy lived in the East. I agreed to try to convince him as soon as possible that the West was the place to live. She, like my Mother, thought me much too young, but, "Never let love, if it *is* true love, slip through your fingers," she said. She had told me many times the story of the one man in her life who had mattered, and who, years before, had gone off to war, never to return. He had been anxious to marry before he went, but she was afraid a wife at home would be an added worry for him. She had waited, and so lost all chance of happiness. Several men had loved her, and offered her marriage, but she had remained true to her real love. This was not what she wanted

54

for me. At the end of that year I decided to marry, and rejoin her at the Coast as soon as possible.

I wrote to her regularly during the few months each year I spent in the East. Miss Carr said that she had noticed in my letters a free, easy way of expressing myself, and suggested that I take up short story writing. I have always been crazy about horses, have always had at least one, and every minute I was not with her I was out with the horse, riding or grooming him. To sit, and write! But I did think she should adopt her own advice, take the course herself, and write. Miss Carr was then only middle-aged; she was brim full of animal stories, all true, that children and animal lovers would like. We had several set-to's about it. She finally agreed to take the course herself, if I would, and said she would gladly pay all fees in order to get me started. I never did start it. Just as the first forms came (there was some delay), my train was pulling out for the East again. So she took the "mail order" course herself. She said she would send the courses on to me, after I was married and settled, and would then correct them herself. But married life was too much for me. As you will have guessed, I had no time.

Later, in 1940, when the heart attacks became worse and Miss Carr was confined to bed, and painting was for some time out of the question, it was to writing she turned to give an outlet to the energy she possessed. Quite often her letters to me would contain short stories that later appeared in her first book, *Klee Wyck*. She wrote them piece by piece, each chapter a story in itself. Her memory was amazing.

HER ANIMAL FRIENDS

CHEESE and apple pie, sauce for a gander, Emily Carr and animals. Some things just naturally go together; when one is present, the other will be handy. Woo, the little monkey, was, I think, through the years I knew Miss Carr, the most interesting of her animals. Miss Carr had had her for years and was very fond of her. Woo was very intelligent and was well worth studying. Like all monkeys she was very sure about whom she liked, and whom she didn't. Perhaps she had learned this trait from Miss Carr herself.

She always wore little full-skirted dresses, that were made for her by Miss Carr. Many were knitted, all very attractive. They were the old-fashioned hoop style dresses of long ago; the full skirts left plenty of room for the active little legs. The leather strap she wore, sometimes as a belt, sometimes around her neck, had a small steel ring riveted into it, that her chain snapped onto. The fact that Woo could very easily undo her chain did not matter; she must wear it! It was amazing how seldom she took advantage and released herself. When she did, she would glance about, over one shoulder and then the other, obviously feeling very guilty and in great haste. "OooOOOHH

ooOOOO," she would mutter, her little lips pursed, for all the world like a naughty child about to raid the cookie jar and wondering how much time remained before Mama returned. Often Miss Carr and I would be behind the door, watching the little monkey. She would get the collar undone, and in spite of her haste would always take time to refasten the buckle before placing it on the floor. She never left it undone! Then off she would go. We never knew till she was on her way what it was she had in mind for that particular raid. Sometimes it would be only a trip to the cage of the parrots which she teased unmercifully if she had the chance and time. The sunflower seeds kept there were a treat for her also, and she would fill her monkey pockets (these are little pouches monkeys have inside their cheeks for just such purposes), spill the rest on the floor of their cage, then give the cage a good shake, mainly to get them yelling, as only parrots can yell. If there had been guests for afternoon tea, and the tray had hurriedly been taken out, out she would go to inspect the partly eaten treats. Lumps of sugar, cookie pieces, anything that happened to be there would go into any room left in the monkey pockets. Every teacup would be carefully drained, any sugar carefully scooped out with her small forefinger, and then she would place each cup back on its saucer but upside down! We never did know why she did this, but had many jokes about it. Her little brown hands were not more than two inches long, yet you have never handled your own best Dresden china with more care. When she had finished, back she would go to her chain, tie herself up, and sit, looking like a cherub. If, as we spied her, we saw that she was

58

about to get into some real mischief, we would rattle the door knob, or stamp on the floor, and back she would rush, quickly put on the chain, and turn her back to the spot the sound had come from. Then she would appear lost in thought, as very absent-mindedly she plucked away at a few folds of her gown, just as old people are apt to do. When we had been away, and had been obliged to leave her for a time, it was very simple on our return to tell at once if Woo had been into any monkey mischief! All that was necessary was to enter the room. If we were greeted with monkey glee, or gloom, or curiosity, then all was well, she had been a good monk. But if she was too preoccupied to notice us, then Heaven help us clean up the muddle we were apt to find! The days she decided to paint were the worst; almost as bad were the times, and there were a few, when she decided to cook!

One day we had seen a pretty little rock plant while walking out by the Gorge. I dug up a small piece of the root for Miss Carr, as soon as she admired it. But in the process I got into a poison plant of some kind, and very soon my hands and one side of my face were covered with a rash. Miss Carr gave me an ointment she had. It was a pale yellow greasy salve, very good for this type of thing, so I kept it in my pocket, and applied a little every time I started to itch.

After a trip one day, we returned to find Woo preoccupied, very intent on the stitches in her hem. But her little hands and face were the greenest little hands and face you could imagine. She had seen me with the tube of salve and thought that any paint tube would do. We had a green monkey for days, and

we had a hard time trying to clean her enough even to save the furniture.

Sometimes on the long walks in the evenings, Mom would take Woo's chain and snap it to CoCo's collar. CoCo was the *most* loved dog. It was funny to see them. Dogs are interested in bones, and gate posts, while monkeys like to turn over leaves and look in empty candy wrappings. Though small, the dog was much the stronger. They would run along a few yards, then the dog would stop short to sniff, and the monkey would nearly take a header as the chain stopped her with a jerk. She soon learned to carry her chain in her hand, leaving a loop always, between her fist and the collar, and in this way she was saved the sudden jerks on her neck or small waist. At first, when she wanted to stop, she applied all four brakes, but the little dog would settle down and pull her right along. She soon learned a very smart trick. At that time most of the sidewalks off the main streets were made of boards. When she wanted to stop, she put on a burst of speed, passed the dog, then, quickly she took up several links of the chain, as close to the dog as possible, and crammed the few links in her fist between the cracks in the boards! The dog stopped in a hurry; he fussed and fumed about, as the monkey deliberately dawdled. The monkey learned very quickly to carry extra chain to protect her neck, and then the trick of jamming the chain into small crevices to hold the dog. But the dog never tried to put two and two together. CoCo never associated, in his slow little mind, the fact that the monkey ran ahead with the fact that he was so suddenly stopped. Yet his capacity for

loving and for expressing his devotion was much greater than hers. Woo would loiter till we were in danger of passing from sight then, because she knew the little dog would really fly to catch up, she'd undo the links, then leap wildly, like a frog, onto the dog's back, where she would crouch jockey style, the loose chain gathered up in one little fist, as she hung on with the other three! The children along the way loved to see them. When we had gone only a short distance, often we found a spot to sit, where we could watch the animals as they played about. The dogs, though clever, were no match for the monkey's active little brain. Miss Carr was always thinking up situations that presented hazards to both, just to see them work their own way out. The monkey often went to the dog's assistance if, for example, he was dragging his own chain while she was loose. If he became tangled, and we pretended not to see his distress, she would go and quickly undo the snarl. If, however, we did let them know we were aware of his plight and in sympathy with him, she would bare her little teeth in a monkey grin, and jump up and down, making fun of him. When she thought he was pulling the chain free, she would quickly tangle it up again.

Often we would walk to the top of Beacon Hill Park, where we could see far out in every direction. The animals loved it up there too; they would run through the broom, dodging and playing, with no chains to hamper any of them. There was no traffic for miles. They would come, monkey and all, at a call from Miss Carr; her "Hi tykes" would ring out gaily, and they would scamper in from every direction.

One day we were walking through our favourite path in the broom, and she asked me what was wrong. She said that not only was I quieter than usual, but seemed sad. I had not intended to tell her, to save her heartache, but her love and sympathy changed my resolution. So I told her of my Mother's old Scottie who had been failing for some time and had reached the stage where living was an effort. That evening I was to take him for his last walk, then to the Animal Hospital for his last sleep. Mom said nothing for a while. Then, "Child, years ago Saint Francis said animals were very close to the heart of God. They must be; I am sure they are. The faith the animals have in us is heart-warming, exceeds by far, very often, the faith we have in each other. It is not so hard to part with an animal we love, when we remember it is dear to the heart of Him."

Often Miss Carr would sing softly as we walked along. She loved to sing; not operatic selections, or current hits, but little ditties, made up by herself to fit the occasion, to her own gay little tunes. She had, too, an easy knack with verse. She could start to write, and go along as if it was a letter, yet when it was read over, there it was, as clear as a bell, and all in rhyme. Very often these verses were done in a little book, illustrated, generally in pen and ink. There her free, easy style is set off to advantage, and is beautiful to see. Years ago Miss Carr gave me a lovely one that she had done in 1895. There were a dozen or more about the studio, but she gave them away to friends. They should be collected and put on exhibition where the public could see them. These easy sketches can be enjoyed

62

by everyone, including those untrained in the appreciation of Art.

Woo seemed to know when Miss Carr was busy with pupils and could distinguish, in some way, between them and the visitors, I suppose by the chatter. She was always very good if work was being done in any form, but to have to sit and be ignored, because of visitors, was asking too much of her. Like a naughty child, she would rather get into trouble and be punished than be ignored. If time passed, with no fuss being made of her, she would quietly slip her collar off and go to the shelf where the papers and magazines were kept. Woo would carefully take a *Liberty*, or a magazine of similar size, that she could handle easily. Then, when it was spread out to suit her, at the feet of the guest usually, she would sit down, and the fun would start. The book would be flat on the floor, her little hands would flip over the pages as she skimmed through, apparently looking for a certain page or picture. To keep the bottom page in place, one little foot would snap up and down, as each page was turned, to hold it firm. Every eight or ten pages she would glance up to see if she had the visitor's interest or attention yet. As soon as she saw a flicker of interest, she would clap the book shut, careful always to leave a finger or a toe in the pages she thought the visitor had been interested in. Then she would clasp her arms around her tummy, rock back and forth, apparently in great glee, laughing fit to burst, in such obvious mirth that even the most serious person had to smile. *That* was her cue! She would then carry on such an exhibition of flirtation and comic mirth that everyone present

63

would soon be weak from laughing, even those who had seen the performance many times. The little dogs would all gather around, staring very solemnly, like little stooges trying to get in on the act. If the laughing ceased, or if the attention lagged, Woo would reopen the book a crack, peek in, slam it shut, and roll on the floor, pretending to be weak, and would continue to play and act up as long as anyone laughed with, or even at her.

Often when Miss Carr was out in the garden, or away, and the phone rang, Woo would take off her collar, let the parrot out if she happened to be locked in, then take off the receiver! The parrot loved to yell into the phone, and she made sense for a time at least. The conversations would go something like this: After several "hello's" that grew gradually louder and louder, at each end of the line, Miss Carr would be asked for, and the parrot would yell, "Who else?" Then there was a pause, during which the parrot and the monkey surveyed each other. Then the parrot would yell, "Speak up, speak up." Another pause. After several more violent "Hello's" and "speak up's" the parrot's yell was so loud that the monkey got nervous and hung up in haste. The party on the line would be left to wonder what manner of woman the artist might be.

Have you ever noticed, when strangers meet your family pets, that they are never able to fool the animals for a minute, though they could fool you for years, about almost anything they really put their mind to? It is a funny sort of sixth sense that nature has given the animal. They know at once if a person is genuinely fond of them. This reminds me of a trait of Miss Carr's, her animal instinct, as she called it. She had a way of

reading people that was uncanny. It worked about anything at all. Perhaps someone would come, intending to buy a picture. Several paintings would be brought in, and set up, one at a time on the easel. Long before a comment was made, Miss Carr knew his true reaction. She did not expect people to like all her work; they were not supposed to; it varied so; but she did expect honest comments about it. If the picture was not one that pleased the guest she would lift it down, put in its place another of an entirely different type. But if a false "How nice," was said, it rang so untrue in her ears that her reaction was almost as if they had slapped her. "Rubbish," she would say; though if they were really interested she would continue to show. If, however, they were just putting in time, as an excuse to get into her studio, Miss Carr soon knew, and she would ask them to leave, as her time was valuable to her.

Much has been said about the pictures Miss Carr destroyed and did not sign. She was loyal enough to herself *not* to sign any that had not reached the standard she had set herself. We have all destroyed things which we considered a failure; if the cake burns, the dog gets it, even if the man next door does like burnt cake. Once, in my presence, a painting was being unframed, to be washed so that the canvas could be re-used. A visitor protested and asked for the picture, as it was so pretty. "I am near sighted and will never notice the perspective," he said. "But all those who see it hanging in your home, my friend, will not be so lucky; some may see well," Miss Carr replied, as she proceeded with her work. We all make mistakes, which we are not criticized for, simply because the public does not

know about them. The fact that the cleaning woman liked a discarded picture was not reason enough to leave it about, to be condemned in the future as "one of that Carr woman's." This was her reply, if the matter was brought up before her.

Perhaps this "inner sight" of hers was one reason why she got on so well with all animals. She had pets of all sorts. Peggy was a white rat that lived for years, happy in a little cage. Joseph was a chipmunk; he lived to be a great age and was a delight to her always. Sallie was a white cockatoo, Jane the green parrot that talked. There were also several budgies, a canary, and some English doves. The doves had been mating and multiplying, as doves well fed and happy do. Miss Carr loved them, had brought the first pair back from England many years before, fearful then lest our Canadian winters be too cold for them. But from the very first they had settled down, and checked all corners of the home she gave them for a suitable spot for a nest. She had given many pairs away to friends at different times. One day her eldest sister, Big, said a friend was ill and a good gift for her might be a pair of roasted doves!

"Be a cannibal if you must," said Miss Carr, "but eat my doves you will not! I do not have my friends eaten, raw or cooked."

She could tell at a glance which were the older birds and which children belonged to which. When giving pairs away she chose always the young ones so that they would not fret for a home they had come to know. She was as concerned about the doves as about her dogs, and recognized their separate

66

traits. If people were as easily understood, she said, things would run much more smoothly. Dogs, pets, are never hypocrites, their only sin being jealousy, usually, and sometimes greed. Although we do try to correct it, inside I think we enjoy animal jealousy. "Being loved for ourselves alone," as Emily Carr often said.

Apart from the domestic animals that Miss Carr was so fond of, there were a number, both animals and birds, ordinarily wild, that knew and loved her. The sea gulls would circle around her garden calling their peculiar call, but would not alight till she went into the garden, or to the open studio window. She could brush her hand along their feathers, or take up and hold a foot, as they stood on the sill before her. A gull is tame enough when hungry to share a meal with almost anyone, but try to touch one some time! The squirrels loved to visit with her; they would romp and scamper about on the little landing on the studio outside stairs. Miss Carr taught me a lot about animals; about their thinking, habits, their loving; their very deep trust and respect; how one has to strive to attain it; and the value of it once it is yours.

Emily Carr is known to many as a famous painter, to many more as a great author; to me she is also a great naturalist.

GREEN THUMBS, OR HEARTS

THE little lawn behind the studio was bordered along both sides by lovely flower beds. The perennials and flowering shrubs, roses of all sorts and every shade, bloomed in a mass of colour. Though they were beautifully weeded and cared for, they had an air of freedom about them. Some of the healthiest, biggest plants were wild flowers that Miss Carr had transplanted and, in her garden, they were lovely. Quite often, after a sketching trip, when the brushes were being unpacked to be cleaned, there, poked down among them, would be a root of a wild flower. Some, in the section they came from, were considered weeds, but in Emily Carr's garden, cultivated, they really came into their own, and the variety of their colour helped to set the others off to advantage.

Indian John came when he felt like it, and worked, for what Miss Carr felt like giving him, in her lovely garden. He had no fixed time to arrive; some mornings when she got up at six, he would be there, his tools and young plants all around him, in seeming disorder, as though he had been there all night. At other times, after an absence of perhaps a month, he would appear in the middle of the afternoon.

When he came late, he dawdled all day and very little would be done. That was why Miss Carr paid him no set wage. His wife, Indian Mary, was a chubby, merry Indian, the type Miss Carr always loved. Quite often, on John's nearly idle days, she would send a gift home to Mary, a dress or shoes, not always new but with lots of wear left. Mary loved these gifts, and John accepted them silently. Most of the Indians were silent people. Miss Carr said, "It is because they have lived with the mountains so long; they have learned the secret of their strength and their silences." John, at first acquaintance, gave the impression that he was gruff and unfriendly. After he had seen me in the garden, trying hard to make something grow, his manner became more friendly. But he did not speak unless he had something of importance to say.

He was slight and strong, and when he came to Miss Carr's in his canoe, he had quite a walk from the bay where he left it. When asked why he did not take a street car the mile or more, he would grunt and say, "Me walk, cars all time slow." Many years before, Miss Carr had stayed in his village on one of her sketching trips. His dog had become very ill and some of the medicine she had with her had cured it. Indian John had never forgotten. One morning he appeared in her garden with some plants, wild ones, wrapped carefully in some birch bark. He had seen her painting trees and growing things years before and he was sure she would like these. His wife, Indian Mary, used to do Miss Carr's washing for her. She had been brought up in Victoria and was well educated. Mary had been coming to her house a long time before Miss Carr knew she was the wife of

Indian John. Hers was the only garden that he ever tended and, as I say, he did it only when the spirit moved him.

The kennels were along the bottom of the garden. They were very comfortable, each with its own shade tree. On Sundays the dogs were all let out into the garden, and how they loved it! All had been trained not to go on the flower beds, and as the young puppies came along it seemed that the older dogs tried to help with their training! If a pup did get into the flowers unnoticed, one of the old dogs would start barking till he was discovered and removed. The kennels were extra large and roomy for the little Griffons, as they had been built for the big, hairy English Bobtails. But as the city grew, and the vacant land on either side became lots, there was no longer any room for the big, galloping fellows.

There were several fruit trees in the garden; the loveliest of them all was the cherry tree. When in blossom, it resembled most a little girl on her way to her first Communion. From the big studio window the blossoms were almost on a level with one's eyes. It was like lace against the sky. Emily Carr's room joined the studio, mine was up a small flight of stairs at one end. Often at night when the tree was in blossom, I heard her moving about, and I would go to the little landing outside my door, to offer my help if it was needed. But, once there, I could not speak; it was as if she were in church, as she stood looking at the tree, there in the moonlight, before the big window.

Miss Carr had painted the tree many times, in oils and in water colours, but she was never quite satisfied. Each effort was a truly beautiful picture, prized by whoever had it, but it

was not "beautiful pictures" that she wanted to paint, it was the awesome holy feeling the tree gave her, which it is impossible for me to describe. But Miss Carr was able to leave the feeling, with the tree, on the canvas. "Only God can make a tree?" But Emily Carr knew just what He was thinking of, when He did it!

Woo was never so happy as when she was chained to this tree. There were always several birds which built their nests there, and these would be carefully inspected by Woo. She would gently change the eggs from nest to nest, while the frantic little mothers flew around, scolding. Miss Carr would watch, from a distance, to referee; she would never stand for any harm, either to the eggs or nests, and often observed with a smile that though the birds were definitely annoyed with the monkey, they were back on their nests as soon as they thought *they* had driven her away. If a human had handled the eggs, Miss Carr said, they would be very apt to desert them for good. The fun started when the young arrived. Some little mother bird, a wren perhaps, would be trying to care for a young robin, nearly as big as itself. Miss Carr always kept an ample supply of food on a flat board on top of a pole, safe from the monkey and the cats.

The tree seemed to use up all its strength on the blossom, as it never did very much in the way of fruit. "Beauty reaps its own reward," Miss Carr would say, as she always did when something almost perfect to see presented itself. "Beauty is to look at every time; if it is substance or effort that is wanted, depend on the plain, everyday things," she would grin and add, "this explains our lack of beauty, eh Baboo?"

Any fruit the tree did bear belonged to the monkey, by common consent. Woo was very generous, and if she liked someone, she would insist that he have a cherry. She would watch the visitor like a hawk to make sure that he was entering her part of the garden. Then up the tree she would climb, and soon have two cherries in her little fists. These she would pop into her monkey pockets. Coming down was not so easy, as she had to be very careful to pass by each branch in the same path she had gone up. In this way she kept the chain free and was able to watch her little dresses so that they did not catch on any twigs. It was interesting, and amusing, to watch her, and it ended up by being almost nauseating, as she landed with a grin before the visitor, and reaching down inside her jaw, she presented him with a nice ripe cherry, gleaming with monkey spit!

I think it was Miss Carr herself who taught the monkey to be so generous. They are usually greedy, miserly little beasts, of the dog-in-the-manger type. I have never seen anyone like Miss Carr. Like a lot of other people, I miss her dreadfully. It hurts, now and then, as I meet interesting new people with the alert, clear minds she enjoyed so much. We always shared our friends, as we shared our books, our hopes and ideas.

It is such a shame that she was not known to many more people; so few really had the chance to know her well. I realize fully now just how much the world really lost when she died. So many people, the world over, have received and will continue to receive, pleasure from her paintings, her books, and the pottery.

One day in 1944, on my last trip West to visit her, she said to me, "Child," (I was past 30!) "do not let the fact that you do not appear in any of my books upset you. I have kept your memory in my heart along with my other true love. The rest, the world can know if it must; these two are mine. You will understand later on. Age is a teacher, Child, a torment, a healer, a living memory, who takes care of her own!" Such a gentle twist to thoughts that hurt a little. Am I unfair, do you think, in telling you things which she left unsaid? I do not mean to be.

While on one of our walks one day, along Oak Bay, we noticed that a small, run-down house was occupied, which had been deserted for years. Miss Carr was glad for the little house's sake. She spoke of its weather-beaten boards and thick walls as if it were a wrinkled little old man. In the back yard was an old holly bush that had been isolated for so long that it had grown long spikes, a fierce courage of its own. It needed no love.

The only other plant near the lonely little house was an anaemic-looking rose bush. All we had ever seen on it were a few yellowish leaves. It was indeed a very poor little bush, that had been planted, loved, then deserted, and had tried for years to be gay. Now it seemed content just to live.

Before long, as we passed that way, we noticed a poor little old lady, as proud as Lucifer, poking about, but so crippled with rheumatism that she could neither straighten up, nor bend right down. Unlike most of the people on the Pacific coast, who are eager to chat, she made it quite clear that she liked to be alone, so we never stopped to speak, as Miss Carr

generally did in cases like this. I used to wonder, often, why she was so interested in this funny, crabby, little crippled lady. If we passed and failed to see her poking about the ill little rose bush, Miss Carr would say, "Wonder where our wee elf is today?" And she would worry, and mention her several times, till our next trip, when the old lady would generally appear. At these times there was an awful, dirty man, fat and greasy, who sat on top of the three little steps at the door; he just sat and held his tummy. His pants always seemed on the point of yielding to the strain, the two remaining buttons seemed always about to pop. He never helped in any way, just sat, and smoked, sometimes spitting far out on the grass. Emily Carr hated him; or perhaps it was all he stood for that she hated. She was always glad for the little lady's sake when he went away. Who they were, or where he went, we did not know, but it made no difference to Miss Carr.

One day everything was very quiet, the next there was still no sign of life. Miss Carr was very upset. Several days passed. She worried as much about the lonely little rose bush as the little old lady, I think, whose poor crippled fingers were not green.

Almost a week had gone by, when one day we saw the mailman coming down the street. Miss Carr stopped him to ask if he knew where the little lady had gone and if she was all right? She was relieved to hear that the old lady had gone to visit a sick sister up the Island, that she would be back in several weeks. Miss Carr's relief was quite evident, but she said no more. We continued our walk in silence.

Very early next morning she got up, saying only, "Come along." First we gathered a bag of droppings from the birds' cages, a supply of fish food, which she kept on hand always for the fish at Beacon Hill Park. Then, from her best rose bush she cut the best branch, wrapped it in a strip of damp cotton, handed me the small shovel and a part of her little collection, and said again, "Come on." She seemed deep in thought; that she was really up to something was quite evident! We were on our way before seven o'clock, a very early hour for the sleepy little Island.

Before I realized it we were at the little woman's house. I do not remember even being surprised. She did all there was to be done there, acting unconsciously, I think, like a surgeon, not saying anything but "This," "That," or "Shovel, shovel, shovel." I handed things as she asked or pointed. It was as if her whole will and concentration were being centred on the rose bush, worked right into it, to help fortify it with her wish to make it live, and there was no strength left to form words for me. Soon the earth had been well dug up around the dry, sad little bush. The fish food and bird droppings were mixed into it, and well buried. Then she cut off a centre branch, the only one on the bush with any pride left! Her own good branch she put in its place, tied it on, bound it securely with the damp cotton, braced it up with the old branch which she had just cut off, and there stood the little bush, looking much better, even in bandages! The other branches and dead twigs she trimmed, some off, some just back. Then we went home. Not a soul had passed as we did our task; Victoria still slept as we entered our own yard again.

76

Our walks for some time were out in the Oak Bay district, of course! The little bush sagged for a few days. We watered it as often as we were there alone. Then one day it began to grow! We had time to take the props away, and most of the cotton off, before the little woman returned, and by that time its leaves were growing and healthy; even the buds were starting.

The little "elf" was puzzled for days. We would see her as we passed, standing, staring at her little bush.

Days later we heard from our Chinese vegetable man that she believed the good Lord had repaid her for tending her sick sister, by making her rose bush grow. We found later that she had been born in the old house, and the rose bush, which she had given many years before to her mother, was only a wild one. No wonder, then, that she was stupefied when the big red roses appeared!

Flowers are a joy, it is said. Well, that bush was as much joy and pleasure to Miss Carr as it ever was to our little elf.

FALLING STARS

WE wish on falling stars as we do with wishbones, I think, whether we believe in such things or not, in the same natural way that we wish those we meet on Christmas Day a Merry Christmas.

When, as a child, I scanned the heavens at night, I remember watching for falling stars and wishing, when they did fall, that they would not have to die.

Miss Carr and I would watch for them, as we sat beside the big studio window on the long winter evenings moulding the clay, making rugs, or crocheting and enjoying the Northern Lights. The stars, it seemed, would grow jealous of our lack of interest, and one would suddenly shoot across the sky, and certainly, for a minute at least, it was the centre of all our attention. We used to wish for silly things, and to make it more fun we wished aloud, trying always to out-do each other.

Miss Carr would often snuggle her little dog up under her chin, as she chuckled, "It is a good thing *her* wishes do not come true, my little Ginger Pop, because *if* they did, there would be no room for us. If wishes were horses, you know!" Her companion's interests were always uppermost in her

mind, whether she was serious or joking; it was never too much trouble for her to include in the most casual conversation things which she knew were important to her guest. It was a natural, wonderful gift.

Sometimes she would wish, just casually, that she was not so stout. "It is not that I overeat," she said, "I guess I just eat too well." And she would sigh, and smile, and a story was almost always sure to follow.

When she told a story of her childhood she referred to herself as Small, and it was as if the actual child was talking. One story which she used to tell me, and which does not appear in her books, I am sure you will like.

One day, in her Father's store, she had been given a bag of English sweets, by a salesman. Each was wrapped separately, with a little motto neatly printed. She saved them till she got home, to show her Mother. Later in the day, her Mother asked Small if she had shared her nice candies with her sisters. Imagine the Mother's surprise when Small answered, "No, Mother, but I saved them *all* the mottoes; they like reading, you know." When Miss Carr was telling this story she would chuckle, "Fat! Well, maybe I am."

One very hot day she had to go a long way up the Gorge on business. As we were busy at the time with some clay orders, it was agreed that she would go on by street car, which ran every half hour. At a set time I should meet her, to carry home the parcels she would have. She dressed in her best, in spite of the heat. Little Woo loved Miss Carr's new hat. She coaxed, wheedled, flirted, and tried all tricks, coaxing to be allowed to

hold the beloved hat! Miss Carr left in high glee. Woo, when she acted up, would cheer anyone on his way.

Her business attended to, she was in the street car on her return journey, when, as they neared the mouth of the Gorge, a strong breeze came up. All the windows were shoved up a little farther to give as many passengers as possible the benefit of the fresh air. As the car was about to start, after taking on a passenger, a sudden rush of air swept Miss Carr's new hat right out of the window! She jumped to her feet, clutching the parcels, and rushed to the front of the car. The conductor, seeing her coming, thought she had missed her stop. He stopped the car where they were, to let her off. She, of course, thought he knew about the hat! As she walked back, looking everywhere for the hat, the car went on. After searching about, she went up to a boy, who was intent on his fishing beside the tracks, and asked him if he had seen a hat, only a minute or two before. "Sure," he said, "it lit right beside me, so I tossed it back in the street car window." He was quite unconcerned and went on with his fishing; as far as he could see, he had done his duty. There was nothing more to be done. She must face either a long walk or a long wait, hatless in the hot sun.

In the meantime I was waiting at the car stop, wondering where she had got to. She arrived on the next car, limping, no hat, her face red (partly from the sun, I will admit!). It was no time for questions, so I took the parcels, patted her arm, and we started home. Late that night, when it was cool (it is always cool on the Island at night), we were at the window, playing with the pets before we went to bed, when a star fell. "I hope

Woo finds *another* hat that suits us," Miss Carr said; then she told us the story! It had been a nice hat, and a very hot day, but I would not have missed for anything the way she told it.

Emily Carr had a sister who ran a private school for small children. One little boy, Teddy, was rather spoilt but this may have been because he was the victim of an incurable disease and had not long to live. He was a dear little fellow, a very nice looking youngster, and we all did what we could for him. One evening as we were sitting before the big studio window working, he came in to visit us before going to bed, as he very often did. The sisters lived around the corner from each other. If Teddy was escorted across the street at the school, he could come around the corner with no danger spots to worry about. Cars were quite numerous even then, and though Miss Carr did not fear them in any way, she would say wryly, "Horse power was much easier to control when only horses had it."

As Teddy sat with us this evening, suddenly a star fell, zooming across the sky in a wide arc, as they do. We made our wishes, aloud as usual. Teddy spoke up very seriously, "May I wish too?" he asked. When assured that little boys generally had very good luck with their wishes, he very solemnly said, with his eyes closed tight, "Gee, I wish I could fish." He sounded so woeful that we all laughed. All but Emily Carr that is; she told Teddy to have a tin, with a worm, ready, and she would take him fishing, she said, the very next day. He was so pleased, and so excited, he asked over and over which star had "jumped" so he could thank it. Childish minds *are* funny. Here I had been sad for years about the stars, that after

granting (I never doubted them!) such wonderful wishes, were lost alone in space, or died, that we might wish. And here was a small five-year-old, with such a happy answer; the stars only jumped!

We all went on the fishing trip next day. No one wanted to miss it. The fact that we were less than a block from the studio did not detract from the adventure at all! The hook was a bent pin, and I was elected to put the worm on the hook, as Teddy screwed his face up tight. Then we gave him his little stick and string, and found a suitable place for him to sit, among the lily pads, in Beacon Hill Park. We all sat. He was so very serious about it, one wondered if he was enjoying himself at all. His eyes never left the spot where the little string entered the water.

"Getting any fish, Ted?" I asked him, kindly, simply for something to say. "No, not yet. I don't think this worm likes fish." He was *so* serious we all roared, except Emily Carr! She got to her feet and was gone in a flash. (I knew later that she went alone all the way to town, to a pet store!) Nearly an hour went by. We were becoming bored, but our little fisherman was as intent as ever.

Suddenly from around the bend a little farther along, we heard her call softly. We gathered our things. Teddy was quite crestfallen. When we reached her, she seemed to be contentedly fishing, with a little stick of her own. "No luck yet?" she said to Teddy. "Well, neither have I. Here, Ted, take my rod and keep it quite still." He was all smiles again, as he sat himself down very carefully. It was only a minute before his line was

moving. He stared a minute, unable to move. Then he jumped up, and danced about, almost scared, too excited to take the line from the water. Very gently Miss Carr showed him what to do, "just," she said, "as real fishermen always do." When the string came from the water, there, tied to it with a neat little bow, was a very small turtle, only about an inch across! Teddy never gave the lack of the pin, or the knot, a thought! He was sure he had caught it. He told the story many times; it was one of his happiest memories. He kept the turtle alive, by kindness mostly, for years. He never asked to go fishing again, but he never failed to scan the heavens at night, for falling stars. He had a long list of wishes, and he was sure that all he needed to make them come true was a falling star.

Teddy lived to be fifteen years old. He loved both the Miss Carrs deeply.

If you had three wishes? If, after forty years of living, we did suddenly have three wishes! Emily Carr used to say that as we grow older we find we had a lot more fun than we thought we did at the time. The worst times, she said, were the ones spent worrying about the things that never did happen!

A star fell this evening as I sat beside the window darning socks. Three wishes? I have only one, and I will have to survive without its fulfillment.

OLD SHOES

IN the corner of Emily Carr's basement was an old box, which stood well in behind the furnace. Into it were thrown the old boots and shoes. They were to be used some day, she said, for kindling the furnace. This was the furnace in the now famous House of All Sorts. There were three complete apartments, besides Miss Carr's own. As you may know, some tenants have a funny way of putting their cast-offs just outside their own door. So their shoes, as well as her own, went into the big box.

The little Chinaman who came twice a week to help with the garden knew the shoes in the box were of no value to anyone except as fuel, so when he was putting the mower away, after cutting the lawns he would always sort through the box. If he found a pair to his liking, he switched them with his own. After seeing many little Chinamen shuffling along in soft little shoes, it is amazing, suddenly, to see one in heavy golf shoes, or white-and-tan oxfords. Miss Carr would smile as she said, "Lee has his false whiskers on today, I see." Indeed, he looked exactly as if he were wearing a disguise; he could not even walk in his usual manner!

The old shoe box was in plain view from the laundry in the corner of the basement. We often used the most recent addition to the pile in the box as a subject for the stories we told each other as we did the washing. We would make up fantastic tales to help pass the time. The condition of the shoes, some muddy, some stained (clean shoes, it seems, are never cast-offs), would give us a clue to begin on. Miss Carr could spin tales of mystery, of buried treasure (for the mud), of gypsies (for the stains), with wailing violin music and generally a sick horse (for my benefit). The cure for the horse would prove almost impossible to get. The great and wonderful treasure would have to be given up. Tears, fuss, such goings-on, diggings in the night, till finally there would be uncovered, glowing like pearls in the moonlight, the Treasure. It would be daffodil bulbs, or something as silly, so that I would have to laugh, and it would be fed to the horse, of course, who would get better at once, only to find the one and only blacksmith had just been knighted. The stories were silly, not hard to come by. Working as we were, our hands and eyes were busy. If our minds were busy, too, making a story from an old pair of shoes, then the time passed much more quickly, and fingers would work and not tire nearly so soon.

If we were modelling, we judged our stories by the number of pots made during the telling. If we made a great many, our story must have been a good one. Does this sound funny to you? It wasn't, it was an easy, happy way to pass the time. A dull brain, Miss Carr said, is of no use to anyone. It is up to the owner of the brain to train it. Brains are like brawn, she

86

said, to be worked and fitted, kept in shape by exercise. "Like the shoes, Child, they all come clean and shiny; it is up to us to keep them that way. Shall we work the polish *into* them, to make them *give* comfort, or neglect and abuse them? The effort is so small, the satisfaction so great. A story, Baboo: the sea gulls are calling. Why?" Then we were off again! One of us would go along with the tale for a time, then say, "Well?" and that was the cue for the other to take over.

Though Miss Carr loved animals, she hated mice, if they came into the house. Traps were used with no compassion then; she would not tolerate the little fellows inside. When she referred to them then, they were "wild beasties." But in the late fall when the rains were about to start, they were her "poor little creatures." All along the garden wall, and under the edge of the fences, would be stuffed many pairs of old oxfords, each with a bit of woolly sock in the toe! I am sure those wild mice families waited for those warm, sturdy little houses to appear. Each would have a family in only a day or so. "The shoes will still be kindling when dried out in the spring," Miss Carr would say, feeling, I think, an explanation was needed, in case *your* shoes were there among those in the garden.

I wonder what those "little creatures" do now that they have no kind soul to care for them? So many people go their way alone; Emily Carr was not one of them.

Another little habit of Miss Carr's, that I loved as a child, may interest you too. When a trap was set for mice, in her pantry, the trap would be carefully baited, the cheese would be tied on securely. But there would always be a generous

87

piece of loose cheese beside the trap so the mouse wouldn't die with an empty tummy, or with visions of unfulfilled promises in his head!

Deceit she could not stand, and to her traps were deceitful. But the mice had to go. "Life can be very hard," she would say with a sigh. "Pass me the cheese!"

PUDDINGS

THERE were several of the happenings to Small that Emily Carr told me about that always pleased me to hear; they did not appear in either of her books which dealt with her childhood. You could live Small's adventures along with her, as the story unfolded. These are so natural I am sure you will enjoy them, as I have done. Though in places they are quite funny to look back on, they reflect the suffering a child can cause herself through an error in judgment, a suffering some adults do not understand at all.

Small had another love in her childhood, besides flowers, birds, and of course, animals. She was mad about perfume, simply yearned for it. Not for her own use, either; that is what was so hard for the adults to understand and what made them so cross with her when, as they said, she wasted it. And do you know how? Some of the prettiest flowers in the large garden had either no perfume at all, or, in some cases, a rather repulsive one. She would go out among the flower beds, smelling this one and that, perfuming any that, in her opinion, needed it. Small was often criticized for visiting so often with the cow, in her cow-yard. The adults did not like the cowcy smell,

so, of course, she perfumed the cow, often, with all she could spare. It seemed to her most unfair that she should get into trouble for this.

Once when she was going to a very fancy Sunday School picnic, she had been washed and groomed to the desired sterile point. She had begged and pleaded with one sister, then the other, with her Mother, and the Cook, "to let her have just one small smell." It was a bit of perfume she wanted so badly, for herself this time, but Mama thought perfume was not suited to little girls.

As the family was entering the carriage, which was drawn up before the door, Small gasped, then turned and ran back into the house. Mother looked at Papa. "She *was* told to go before we left the house," she said.

Small ran quickly into the kitchen; she knew just where to find it. She got up on a chair, looked into the cupboard; there it was! Quick! She got the stopper out, tipped the bottle up, on the front of her nice white party dress. It slipped, but she grabbed it before it fell, and put back the nearly-emptied vanilla bottle. There she was with a great stain like cold tea, right down her front! It still smelt very good, though. She ran out and jumped quickly into the place left for her. In the flurry of leaving, no one noticed, for a minute, her predicament. Then, "Who brought the pudding?" someone asked. Eyes and noses started turning here and there. Poor Small, the stain and her sin were soon discovered. After a scolding, it was decided to make her as self-conscious as possible. "You will go to the party as you are. Try to act like a lady. We cannot

help your smelling like a pudding." Poor little sensitive Small! It certainly cured her of her addiction to perfume. It was, I suppose, like tying a dead chicken around the neck of a pup which had killed it.

There is another story, still smelly, that took place before this cure came about. On her Father's dresser, one day, she noticed a fine, new, very pretty bottle of green liquid. The design was in itself a fancy affair, just the kind to catch any child's attention. She smelt it. It *was* delicious! The cork was in much too firmly for her tiny fingers to loosen, so she put it in her mouth, to hold it firmly with her teeth. She turned and twisted the bottle, as she worked on the cork, taking it from her mouth every little while to have another good smell! Suddenly, with no warning, the cork fairly shot out, spilling the green liquid down her chin. She ignored it, and had started putting some on this ear, on that elbow, as she had seen her older sisters do, when her Mother came into the room. "What *are* you doing, you silly Child?" she said. "Put that down at once. It is your Father's new hair restorer! Do you want *hair* all over yourself?" Poor Small! Only she knew it had been spilt on her chin. She watched for days, for the beard she was sure would soon be sprouting, in spite of the terrific scrubbings she had given her poor little face.

This little story I really should start for you in Emily Carr's own manner, it seems to fit so well! But then, everything she ever said, according to my standards, always did fit well! I am sure you remember how all our stories started when we were small: "Once upon a time . . ." Well, not so Emily Carr.

The beginning had to fit what we were speaking about, and according to her standards it always did. If the story was about me, it would begin, "Once upon a horse, there . . ." In the case I am going to tell you about (remember, please, that Emily Carr was one of several sisters but much the youngest, only half the years of the older girls), she started her story with, "Once upon a quarrel, when Small again came out second best . . ."

Mothers often have a hard time settling quarrels between the youngsters, and it very often happens, what with potatoes boiling over or the supper nearly ready to be put on the table (quarrelling gets more heated when tummies are empty!), that there just is not time to hear both sides of an argument. Very often, it is not the guilty party who is told to sit on that chair! So it was with Small. Her Mother was not aware of what had taken place, but to restore peace quickly she spoke severely to Small, sending her to her room. According to the light Small had on the whole affair, it was in no way her fault and was very unfair. Her heart was broken, as she was sure they no longer loved her. When found by her Mother a little later, she had a small box on her bed. Into it she was carefully putting her cherished patty-pans, paints, and three small monkeys, "Hear no evil, Speak no evil, See no evil," and an empty, treasured, still-smelly perfume bottle. It was quite evident what was in her hurt little heart and mind. Mother said nothing for a minute or two, while Small went right ahead with the serious business at hand! Finally Mother said (after what must have been very serious thinking, for she knew her little girl very well, and her love of food!), "Emily,

92

if you are able to wait a few minutes, Cook will fix you a few sandwiches. It is a shame you will miss dinner, as it is one of your favourites, but you know best, dear. Call at the kitchen for them when you are ready." After a time of silent thinking, the treasures were very slowly put away again. The usually closed door at the top of the back stairs had been mysteriously left open, and the dinner did smell very good. Anyway, she was not so mad any more.

Child psychology has quite recently been thought of, they say, yet this incident took place over seventy years ago.

Here is another happening of long ago, but this time the laugh was on me.

I had been boarding at a girls' school in Victoria, till Miss Carr and I had become so friendly. When I went to stay with her I continued my schooling there as a day student. I was usually good, simply because I had a horror of being kept in. As soon as school was over, I would race off, exercise my horse, then go to Miss Carr's for the day's real excitement. The painting lessons, walks, talks with Miss Carr all were events. There was sure to be something pleasant on the day's programme. It is funny how children can so easily put their whole soul into whatever they are interested in at the minute and concentrate with their entire being. That is the hold Art had on me at the time. I had loved it always, but with Miss Carr as my teacher, each lesson was a joy; the variety was so great from day to day there was never any monotony. Always, as I mounted the studio steps, a feeling of expectancy would grow, till, on the top step, I would nearly burst! It was the

way it used to be when, as a small child, I neared the tree on Christmas morning!

I have a great love for music, though I am not at all musical myself; my singing, I know, leaves a lot to be desired, but I love to sing. When I was a child, if I concentrated very hard about anything at all, I would start to sing. The harder the problem, the louder I sang. When it happened in school, it was awful. The teacher in this particular class was a dear little old maid, very homely, but as nice as she was plain. I thought a lot of her, to make up a little, I think, for the way some of the very pretty girls snubbed her. Still, when I was doing work I liked, or was having trouble with, as soon as I started to concentrate I would start to sing. It must have been very exasperating for her. She liked me too, I know, but of course it had to stop. One day she said, "Miss Williams, if you sing again I am afraid you will have to come up before the class." Everyone fairly gasped. That meant only one thing, and after all we were in high school, and things like that just did not happen, not there, not to girls our size! The shock of the thought of it kept me quiet for some time, then there was a Latin question that had me completely stumped; and so I sang!

"All right," she said, "Miss Williams, come up please." It seemed a mile to her desk, but I made it. Did you ever have a dream that you were trying to walk, that your feet stuck to the floor, each step taking all your strength to manoeuvre? Well, it is worse when it is no dream! She slowly unlocked the bottom drawer of her big desk, slowly took the big strap out (it was the first time we had ever even seen it), and as slowly stood up. She

looked at me a minute. Then she turned the strap about, and handed *me* the handle, saying as she did so, "Let us be true to each other; I am too fond of you to strap you, my dear; it will do as much good, I think, if you strap me. Three on each hand, please. Hard." I nearly died. There was an audible gasp from the class, then you could have heard a pin drop. I felt as if I were sinking into the floor, and *hoped* it was so! My face was so hot, I was sure I would weep. The little teacher stood there; she was not over five feet tall, but she seemed to be towering above me then. "Well?" she said, "I am waiting." Still I stood. Finally, she reached out, gently took the strap from me, and put it away. "I think that will be all," she said. Believe me, it was. I never sang in school again. Indeed, it was years before I could sing anywhere and not think of her standing there! Not a word was ever said to me about it by the class, but they understood, and were much nicer to her ever after.

I was so quiet at my painting lesson that afternoon that Mom asked me what was wrong. I always told her everything.

"I would like your little teacher," was all she said.

THE GUEST ROOM

THERE is no need to describe here the care, pride, and joy that boil up inside every young bride when the first guest is due and his room is being made ready.

The first year of my marriage, I was lucky that my family lived near me and I could see them often. My luck continued, because the first visitor to spend some time with me was Emily Carr. She was coming all the way from the Coast. Was I the proud one! The fact that a west coast show was being held here in the East, and Miss Carr had been invited to exhibit and to come East to meet the members of the Group of Seven, did not slow me up at all!

A great box had arrived from her when I was married. It was a Treasure Chest such as we all dream of but few see. This was in the old days, when she was still well, and she made most of the things herself. There were several oddly shaped cream jugs (she knew so well my love for, and taste in, china!), a lovely, soft, brown rug, made by her, beautifully done, a supply of her own Mother's table silver, and a lovely water colour, mostly blue, of a spot I was very fond of along the coast. There was a dear little pewter mug (I wept over this one; it had

been given to her, when *she* was eighteen, by the soldier who had been killed.) There was also the fine nightie she had had for years; she loved it just for the vacant spot in her life that it represented, I think. I was proud, glad, and at the same time sad to have it. If I had had a little girl, it would have been one of the things she would have had.

There was a common can-opener, all wrapped up as fancy as you please, with a great big card tied to it. The card had a drawing of *me*, painting at an easel in the corner of a small kitchen, with a *big* clock on the wall, the hands pointing to twelve-thirty, and the face of the clock was drawn in, with eyes and so on, representing a "you'll be sorry!" look! At the table sat a man, in overalls, the picture of disgust, as he stared at the clock, his elbows on the empty table! At this time Miss Carr had never met my husband. I had not referred in any way to his attitude toward my painting because we had been married only a month or so, and at that time there *was* no reaction to refer to. When, years later, I asked her how she knew in advance, her reply was only, "Human nature, Child, and different environments." At that time this hardly made sense to me at all. But painting had stopped in the third year!

In another separate box was a little ginger-coloured Griffon. He was only a small pup, the sweetest little thing! The beautiful Sugar Plum was his mother. There had been five puppies. Miss Carr said that they were such heavenly little things, "there were no two ways about it!" and so she promptly named them Cloud, Sun, Moon, Planet, and Star. This was just like her! She sent me Sun, because, she said, he was the

warmest and the brightest! Her easy way of tying things together, having the right thought in her heart and the right word on her tongue, was a gift, I think, even more valuable than her gift of painting. Indeed, in my heart I am sure it was because of this understanding of hers that her paintings are so loved today.

Sun was a dear little fellow; even when full grown he was no bigger than a small cat. The people of our northern country had never seen that particular breed before. He was a great favourite, and the butt of many jokes, with his funny little pop eyes and turned-up nose. I had had him only a little more than a year, when some tourists, going by, stopped, and put him in their car. That was the last time we ever saw him. Having to break the news to Miss Carr hurt me nearly as much as the actual theft.

Only a little more than a month after these things arrived, Miss Carr received the invitation to come East for the show. But we pretended she came to visit me; the exhibition would be "seen to," later on, if time permitted. Her imagination worked all the time; in this case she wished to help a girl still not too sure of the road she had chosen. So we made a joke of her trip, and we laughed together, almost ready to cry because we *were* able to laugh together!

Miss Carr had so many sides to her nature that it seems impossible to describe even the smallest detail without getting involved in the biggest descriptions. Do you remember the story of the seven blind men and the elephant and how different their descriptions were? Well, if Miss Carr was being

discussed by a group of people who had met her casually, in various circumstances, their impressions would be just as varied! It is because I loved her so, that it is hard for me to get my point across, with words alone; it is as if I need gestures very often to help me!

In the week before Miss Carr was to arrive, the menus were a great delight for me to ponder over. I had all sorts of delicious things in mind; her tastes were so familiar to me. Miss Carr, as well as my Mother, were both very good cooks; both had taught me a great deal, and I, too, loved to cook.

As it turned out the meals, for the first few days, were only snacks! We had so much to say to each other!

Among my horses at that time was a wild little buckskin mare that my husband had given me when we were married. Her main joy in life was to see how far, and how often, she could travel on her hind legs while waving her forefeet in the air. In Kinmount, where we were living then, the snow was quite deep, so we did our travelling in a cutter, complete with robes and bells, plus the little mare with the gay hind legs! Miss Carr, then about fifty-four, had not been in close contact with horses for nearly twenty years! But this fact did not daunt her at all. She would jump into the cutter, grab the robes gaily, and call, "All aboard, little Fly, wave bye bye!" Miss Carr would laugh aloud, as up would come the little mare. She would balance a minute, then the sudden jerk, as she plunged forward, to be off like a shot! She was a Standard bred mare, but a trotter, and speed was her middle name. Miss Carr remarked, after her first ride, that our Fly was very aptly

named! There was never a word from Miss Carr about going too fast, and it did tickle me when she asked, "Baboo, do you think she would mind if I drove, it has been so long—" And did she drive? Of course, just as well as she did everything else. I do not think I was even surprised. I do remember being so happy that she enjoyed it. After being on the West Coast for so long, where the weather is so mild, and never enough snow for a cutter in the part Miss Carr came from, I had wondered what she would think of our means of transportation.

The barn was about a hundred feet from the house, and due to the number of animals we had there, it was a more even heat, warmer, than was our old farmhouse, heated as it was by stoves. My Springer spaniel bitch, a beautiful, well-bred animal, had been moved out there because she was nearly due to have puppies. She had come from the Avondale Kennels, in the West, and for that very reason, I think, Miss Carr loved her at once. Springers are, to me, the very tops in dogs, just as the big, hairy Bobtails were to her. But the spaniels have the same soft eyes and lovely disposition and, to my mind, are the closest thing to the Bobbies. Anyway, Miss Carr loved my Raggedy Ann. During the day Rags was in the house with us, but she went to the barn at night. She was very fond of the horses, and was very content there. She loved little Sun and was very good to him.

Often at night, especially if there was a storm blowing up or if the wind started to howl, Emily Carr would get up, put her coat on over her nightie, my husband's over-shoes on over her slippers, then go out to the barn, through the snow, to sit

with Rags for a while. I think she visited with the horses, too; often in the morning, after one of her busy nights, we would notice the oat bin open, and the horses would have a very self-satisfied air about them, and a gleam in their eyes!

There are several old Dutch families in Kinmount, whose parents or, in some cases, grandparents, had settled there many years ago. Nearly all of the old generation are gone, now, but they were great friends of our family. They had farms, and the usual livestock, though theirs was generally much fatter than that on most of the farms in the district. The homes of those I had come to know very well glowed with the warmth only genuine antiques can give. I had told Miss Carr of these lovely treasures many times, and of the gentle people, just as I had told *them* of my Artist friend, in the West. It seemed too good to be true that now these friends should meet. Not wanting to embarrass the kindly old people, by pointing out their treasures, I had told Miss Carr where to look, in the nice clean homes, for the lovely things. Their only value to the owners, who were in no way mercenary, was the fact that they had come from their homeland, with their parents. There were sterling silver articles, and cut glass, that would make any dealer itch to get his hands on, and a lover of fine old things sorry for them, that they were not loved for themselves alone. They were high on shelves, half-hidden, or in behind cheap china in a corner cupboard, when they should have had a prominent spot of their own. There were also some very fine pieces of old pewter; I knew Miss Carr would be especially interested in these.

Their own handiwork was beautiful too. The window blinds had the nicest pieces of work, not lacey, or frilly, but a panel of good, strong crochet, pictures of pastures, trees, cows and horses, all worked in with those strong, steady fingers, on the long winter evenings, and by lamp light. Their beds were covered with lovely, hand-made bed spreads, made of string, but long-wearing and beautiful to see. The floors, like Miss Carr's, were covered with hand-hooked rugs, each design different. Miss Carr was as impressed as I had hoped she would be. She knew too well it would be an insult to offer to buy any of their treasures, though there were many I know she would have loved to have had. The old pieces are gone now, as are most of the dear old people. As very few ever married, I often wonder what became of the memories!

Just after we had moved into the big farmhouse my father-in-law had given us as a wedding present, quite often at night we would hear funny, high, squealy noises. We were unable to identify them. They were like the wind at times, but they sounded when there was no wind, like canaries singing in the night. We became used to them, and soon forgot them. Not long after Miss Carr came, the noises started again. She listened a minute. "O Baboo, what lovely mice you have!" she said. I was very surprised. Mice? We had seen no traces of them; they evidently stayed in the walls, which were very thick. And I had never heard of mice singing. I was sure she was fooling us, but she explained that mice always sing, but in a tone so high that our ears are usually not able to hear them. These little Kinmount mice must have been the basses. We got

a great laugh from our singing mice! Later, people came from all around, just to hear them. And, as is generally the case, on these nights the mice never sang!

There was never a dull moment during her visit; our only grump was that the time went so quickly, it was over too fast. But I think you know now how nice my guest was to get along with. Rearing horses, howling winds, inexperienced house-keepers, and singing mice, none of these daunted Emily Carr.

Her next visit was in the summer about two years later. My son Joe was the attraction then, and we had fun then too, though not nearly as much as we had had in the country. At that time we lived in Oshawa. We had had on our list, for years, several things that we must do, if ever we were in Toronto together. One was to visit the Art Gallery, and the Museum and, of course, the Zoo. We got to the Zoo just at feeding time one afternoon, and because I knew Dr. Campbell and some of the officials there, we were allowed to stay and follow along. The animals were eager for their food and worried lest they miss their share, and at times the keeper was completely mobbed. Miss Carr asked him, when he stepped out into the aisle to refill his basket, "Can you tell me, please, are they following you, or chasing you?" He did not seem to have an answer, but Dr. Campbell laughed.

Three times she came East. She always said she came to visit me, always continuing her little joke. We had great fun together when she came. Then her heart got worse and she was unable to travel. After 1935, on three occasions she sent me a return ticket, to go and visit her. About that time my

health was bad too. I had had several operations and attacks of pneumonia. The fourth time she sent tickets, things were a little better with us, and I returned the ticket to her, but we got others and my husband went West with me. It was his first visit and he loved it.

Each time that I was with her I would rent a "U-drive" car and take her far out into the woods she loved so. When she was too ill to walk we would get a strong man to carry her to the car. These trips were against the doctor's orders, but she did enjoy them so, and would beg me to take her. When she was out, she would sketch furiously when she was able to; then, at home, her board propped on her knee, she would paint at her leisure. One sketching trip would keep her painting for weeks.

When she was able, we would go off for long walks, Miss Carr in her wheelchair. Her resentment and hatred for the chair were understandable, but it was comical to hear the things she would say about, and to, and at it! Her great love for the outdoors overcame her "chair phobia" as she called it. "Anything is better than nothing," she would say, "bring on the chair. On James!" She would grin in spite of herself, as we set off.

As we went we carried on what, to others, must have sounded like a very odd conversation. She was always worrying about me, and suggesting stops, so that I could rest, very tactfully of course. Perhaps she would say, "Stop just a minute; the bloom there in the shadow, I must study it a minute." And again, "Tired, Baboo? Get in for a while, it is your turn now." We would both laugh; you couldn't *stay*

tired, pushing her. "What colour is your horse today, my Pet?" she would ask, which meant, of course, where were we going? There are so many steep little hills around Victoria that the number of places that one can journey to in a chair is limited. And the fact that we were both so fond of horses, just to talk about them seemed to give me strength and make the trips easier.

If the weather was good, we would sometimes take a lunch, and she would plan and rewrite the menu as carefully as if it was for a seven course dinner! Being idle after so many active years was harder for her than the nights of pain. She got much more satisfaction out of the thought and planning she put into the lunch than she ever got from the actual eating.

"Baboo," she said one day, "I had no idea you were so fond of picnics; nearly every day you suggest we have one. I feel badly as I think of all you have missed, but we'll make up for them." She meant the days we had spent sketching and painting, when we were loaded down with material and never gave a thought to food, partly, I guess, because we were completely immersed in our work. She was referring to times twenty-odd years before. I was pleased to think she interpreted my suggestion that way! My worry was that she would see through me and the joy would be gone from her planning!

She had me find some stringy crochet cotton, which she had put away years before "in case of an emergency—never thinking *I* would be the emergency," she said, with the old twinkle! With this she spent several days, when her strength permitted, crocheting a little string bag, complete with a

pocket, that could be tied to the back of the chair. The pocket was for the thermos. She derived no pleasure simply from "making"; there had to be a use, a purpose, in having the article, before she would start it. And her strength had failed so that holding her hands up, with the hook and string or wool, was often too great an effort.

With the lunch that she had so carefully planned packed, away we would go, up the Gorge perhaps. That was a favourite route, through Victoria's Chinatown, with the quaint little stores, odours (not all little), signs, and little people. Mom was very fond of the Chinese and they, like the Indians, respected, admired, and loved her.

We would often stop at the doorways and she would talk for a minute with this one, and that. "Hello Charlie, today no rainie, today lots sunie," and they would laugh together while a youngster would be sent into the shop hurriedly for a handful of the paper-shelled, raisiny nuts they always seem to have on hand.

One day a small boy had been playing at the roadside and his parent had failed to notice his dirty hands. As the gift was offered, the dirty little hands were very prominent! "Ho, no good, Boy, no good," said the father, in reproach, carefully taking them from his son's hands. He proceeded to spit on each, carefully, then from his large and flowing sleeve produced a linen cloth with which he polished them and, in great pride, handed them over! I stayed directly behind her chair! To have caught her eye then would have been fatal to us both!

A trip up the Gorge meant a trip into the Chinese Gardens, where there were always birds and animals that enjoyed our newly received presents, polished or not!

Miss Carr loved the tall hills, and the deep shade, which made the shadows purple, and the tree tops that shimmered with almost yellow lights. When we had reached a spot with a particularly fine view, I would say, "The old horse needs his girth loosened," and would sit at her feet, pretending to puff! If I did not seem to need the rest, she hated to ask me to stop. I never could make it clear to her how much I enjoyed our walks until once, only a year or so before she died. The sister, Middle, had been all her life a school teacher, and one day I happened to pick up one of her school books. It was beautifully illustrated, printed on rich paper, but the printing was in German! It was the simile I needed! I put it away, saying nothing at the time about it. But, only a short time after, there was something on at Beacon Hill Park, which she wished to attend. "If only I did not have to rob you of your time, Child," she said. Quickly, I got the book. She looked at it a minute. "Yes?" she said. "Well, Mom, going places alone is like looking at this book; nice views, rich surroundings, but the meaning is not clear. With you along, the picture is complete to me, the meaning solved and waiting. Don't ever say any more about it, Mom." "Bless you, Child," she said, and kissed me, and gently took the book from me. It was on her table nearly two years later when I went out to see her for the last time.

Before becoming so ill, Miss Carr had loved to cook and was a wonderful cook. Curry, spiced dishes of any kind, and sponge

cakes were her specialties, I think, but anything turned into a most delightful meal when she was in the kitchen, whether it was yours or her own. When she was painting hard, her meals were scanty, but between pictures each meal was a masterpiece, an event to be remembered by those lucky enough to share it.

The oldest Carr sister, who was Big in Miss Carr's stories, was really a little bit of a person, weighing, I am sure, not a hundred pounds. She was a trained nurse, with some special degrees, and very efficient. When she became ill herself, she was quite sure that it was nothing serious. All her life she had looked after others, and she resented others trying to care for her. Middle always made the bread for her own use, as well as for Big and Small. Mom, trying to help and knowing junket to be good for people needing extra nourishment, got a supply of tablets and made up one bowl, which she proudly presented. But Big resented the effort, saying she did not care for it just then. While they were discussing it, her doctor called and he was pleased to see the junket. He said how good it would be for her and that she should have a pint of milk made up every day, as well as the rest of her diet. Mom was pleased. Big was cross. At last Big grudgingly said, "Well, leave the tablets here; I know when I feel like it, you don't. I will use them, I promise. You are very good." Mom never did forget her resentment, because Big never did make any junket! But every day she took a tablet then drank her pint of milk!

They were wonderful days, all of them. First, receiving the training from Miss Carr, in her home, then having the opportunity of doing it in reverse, and entertaining her in mine.

BUTTERFLIES

EVERY little while there crops up a saying that seems so right for the occasion that you wonder who in the world thought of it first. It seems to fit so perfectly it makes you sorry it was not you who thought of it, but leaves the urge to come to know the composer of it. That is the way with the expression "butterflies in the tummy." Have you ever had them? Then you will understand fully just how aptly the saying fits!

Miss Carr got them often, various breeds though, that all affected her quite differently. The worst were the black "worries," which I will tell you about later; the most active were those which were, she said, crossed with lightning bugs! "One of us is always looking for a spot to land!" was her way of explaining them to me. These were active when there was the slightest prospect of an elevator ride. Even the knowledge that there was an elevator in a building she was visiting, she said, caused them to gather!

On one of her visits East, about twenty-five years ago, we were in Eaton's big store, in Toronto. I was not aware then of this aversion of hers, as she was shy about mentioning it. The fact that we had never entered an elevator when we were out

together had not dawned on me. As we were passing a stair-way, or escalator, very casually she would suggest we go either up or down, as the case might be, and I had never tumbled that she did this on purpose! In Eaton's, this day, we had done a great deal of shopping, and were both loaded down with parcels. I was walking ahead, making room for her through the crowd that is always there. We neither of us had very clear vision, as the parcels, though not heavy, were bulky and were piled up on our arms. An elevator going down had just stopped, the people who wanted to had gotten out, the others were well back in the car. When an elevator stops in Eaton's, no matter how empty it was a second before, people seem to pop up out of the floor in front of it! I followed the crowd into it, and the rest of the crowd followed us. We stopped walk-ing, of course, but Miss Carr evidently thought only that we were held up a minute at some sale counter again! The door closed quietly, we were still carrying on our conversation, all jammed in together, when the elevator started, with a sudden jerk and drop, as they usually did years ago. Up went Miss Carr's hands; the parcels flew; she squealed, then sat down stiff-legged right where she was! And there was no room! When we were all standing, we fitted nicely, but when a short plump little body suddenly sat, she took up four times as much room; her fat little behind was solid, and she just stayed put! We were all off balance, the poor operator had been knocked away from her switch, and could not get back to it in time. We seemed to hit a huge spring, with quite a thump, and we shot up again, out into the wild blue yonder, or so it seemed!

By this time everyone was talking, shouting at once, grabbing at everyone else, in an effort just to stay on their own feet. The poor operator finally got the thing under control, and got it stopped and lined up with a floor! She opened the doors; we practically fell out! The crowd waiting got the shock of their lives as we tumbled out. Such a turmoil, hats off or awry, purses and parcels all about, everyone hanging on to someone else, obviously a stranger; and everyone talking, but not to any one person! When the dazed crowd finally got out, imagine the utter amazement of the waiting passengers, to see, sitting on the floor, feet out at legs' length, hat over one snapping eye, surrounded by parcels of all sizes, a hot and bothered stout little lady. Certainly not a person in the crowd had a hint that she was Canada's most famous Artist! Everyone was very good about helping to get her sorted away again. The sales girl from a nearby counter brought a large shopping bag, and smiled as Miss Carr asked if there was one large enough for her to crawl into! You could always count on her to see, and make the most of, the funny side of anything, even if the joke *was* on her, and in spite of the "butterflies!"

But, as we made our way home, she did say, as she chuckled, "Well, Baboo, I *am* glad Lizzie did not see me then!" Lizzie was the sister referred to as Big in Emily Carr's books, the older sister who took it upon herself to discipline Small, and continued to try to do so all through Miss Carr's life.

The little yellow butterflies were not so bad, she said. They were the heavy little fellows that weighed on her mind, from the time she spied a new bird's nest. Because of the number

of lovely big shade trees in her garden, there were naturally a number of nests, each of which, if occupied, was as much on her mind, I am sure, as on the mind of the new little mother. Miss Carr could tell at a glance what breed of bird had built the nest, by the construction, as we tell trees by the leaves! She always spoke of her awareness of the nests, and their hidden treasures, as her yellow butterflies. Every time she discovered a new nest, especially a new type of nest, she seemed so pleased, I am quite sure she rather loved even the little yellow butterflies, and that she hugged them close! When a love is big enough, it can easily support an added worry!

When the butterflies came, she said, they could quite easily be classified. Miss Carr had her own name for each of her worries. The big black ones with the spots, were, she said, the bad ones, that would some day develop ulcers in her middle! They were the ones that moved in when the kiln had to be lit, and fired for from three to five days, depending on the type of pottery. It took several days of steady firing and heat for the oven to reach the desired temperature, after the kiln was lit; the heat had to come up so slowly, then when a white heat was reached, it had to be held steady for a given time, then gradually reduced again. If either rise or fall was too sudden, the clay would crack. The kiln was, of course, specially built, and heavily insulated; the danger was always that a spark might start trouble. She had had several small fires, even when every precaution had been taken, so that she was always on guard and really had reason to worry. The weeks of work, gathering the clay, weathering and washing it, and

moulding it into the various shapes, all these represented a lot of slow, tedious work, and the outcome depended wholly on the firing process. The fire had to be attended to every two hours, all night, as well as all day. The broken sleep, added to the worry, was the cause of the remarks of Middle, the sister who was the school teacher. "The butterflies that Emily had at these times were very bad tempered ones; they might even have been bats!" she would say, when speaking about it later. They were very fond of each other, but they *were* outspoken!

The butterflies that gathered before one of her exhibitions were more like moths, the way they fluttered about, softly, but around and around. The long nights, after a show, were almost brittle, like everlasting flowers. And the way the nights dragged on, the air seemed brittle too. And that would be the morning the paper boy was late! With the daylight the moths had changed to butterflies, of course, very active, jittery ones, that made breakfast impossible, so the time it normally took to eat it had to be added to the waiting! Still there would be a joke all ready! She said she had it all figured out, why she felt so uncomfortable, because, you see, her butterflies had been crossed with rabbits! That was why they jumped so high, and the reason they multiplied so quickly!

You know the funny sensation you get when someone, in all seriousness, tells you something, using perhaps a wrong word, quite unaware they have done so? Then, you nearly choke, trying to keep your voice calm, your face straight, and trying hardest of all to place it away in a corner of your mind, to bring out and enjoy later. Miss Carr called this funny

115

feeling her grasshoppers. We might all be talking together, several customers, Miss Carr, and myself that is. One of them might say something of this kind. I would busy myself with my back to Miss Carr for a minute, then, as I faced her again, all composed, she would be very apt to say to me, "Did you notice that grasshopper, Baboo?" There would be a wicked gleam in her eye, but of course those present would not notice anything strange in our conversation! Once a reporter called to interview Miss Carr. She was from the States, very nicely dressed. The maid at the time was always using big words, trying to impress everyone. As she returned from showing the visitor out, the maid turned to Miss Carr and said, "Well, she sure was extinguished!" Miss Carr remarked later, "I had no idea I was so obvious about it!" We had no trouble at all finding things to keep us laughing. They just happened!

This same maid had come from the prairie after she had finished school, to find work. She had been in a small restaurant for a while, but was too clumsy with the dishes to last long there.

Miss Carr had only been back from the hospital a short time and was not at all well. To explain why she seemed uninterested at times she said, "Forgive me for seeming so stupid, but you see I have been drugged." The girl's eyes fairly popped! "You have?" She seemed so completely thunderstruck, Miss Carr said, "Yes, I just came home from the hospital." The girl said no more about it then, but she was very kind and tried to be more helpful than she had before. A day or so later, the topic came up again and the maid said, "I was drugged once,

I was darn near killed." Of course Miss Carr asked what had been wrong that they had drugged a young person like her. "Gee, Ma'am, where I come from, it's mostly the young ones that gets it! My horse shied, and my school-bag caught on the horn of the saddle, and I sure was drugged. What happened to you?" Poor Mom! As she said, "Give me time, I get them all."

People who spend a lot of time alone understand their feelings and emotions better than the rest of us. Some dreams are so lovely, they ought to be shared; Emily Carr's were. She would paint a picture, with her soul there for you to see. "There are lonely places in every soul, Child; they are the soul's greatest strength," she said to me when I asked how *she* was able to put the deep feeling on canvas that she did. My soul was not old enough, then, to share its lonely places, she said.

Many years ago, when Miss Carr was herself a girl, she had studied in San Francisco. Among the other students at the studio was a little hunch-backed girl that Miss Carr both liked and was sorry for. She had a habit that we often spoke of. The other students paired off in twos and threes, but the deformed little girl, who was eager for love of any kind, was generally alone. Quite often the class would go sketching, by tram, or boat. The hunch-back would slip up to any child on the dock and give her a penny just to wave! When one of us was sorry for herself, for any reason, the other would say, "I'll wave—for a penny!" The skies would clear at once. But it was sad to think of the forlorn little butterflies that the hunch-back must have had. Miss Carr was so glad that a stray kitten she found one day and gave to the poor little girl returned her

love. Even when she was a child, Miss Carr had a sensitive nature; not many young people would have thought of the hunch-back girl in connection with the stray kitten. Not many would have taken the trouble to help a kitten; a pat and, "Aw, poor kitty!" is all most young people have time for. There were times, when in the woods, or painting trees, that Miss Carr would refer to her heart as a bunch of cedar buds. Well, if she did something that she knew I was not sympathetic about, she would say, "Blame my cedar buds, there is a worm in them no doubt." My reply would be, "The nicest butterflies come from the fattest worms!" We would laugh; but when the shoes were first put in the garden for the mice, the rose bush made to grow, the turtle put on the little sick boy's fishing string, I used to wonder if maybe the little butterfly hadn't already hatched, and I was happy just to live right there, in a heart so big and warm.

TIDES, SANDS, AND WIND

IT was in the fall of 1941. We had gone miles, or so it seemed. Emily Carr was in her wheelchair, breathing much more easily because of the fresh air, in spite of the strong winds that did their best to blow her rugs out to sea! It had been early morning when we had set out, our lunch packed. The absence of the dogs and monkey was banging at our hearts, leaving a hole in the middle of what would otherwise have been a lovely day. We kept the conversation going, afraid to let it lapse as we usually did so easily. Each knew the other would not mention the animals, but each wanted to save the other the suffering a silence caused. Their absence was as vivid as an electric sign flashing off and on, on a dark night.

It had been nearly six years since I had seen Woo. When illness had taken over the planning of Emily Carr's life, the little monkey, after careful thought, had been given to the Vancouver Zoo. It had been in the winter, and a trip East, to me in Ontario, would have been too much for her. Monkeys require a lot of attention, and Miss Carr was so thoughtful, always, of those caring for her interests, and did all she could to lighten their duties even though, as in this case, it nearly broke her heart.

The Zoo authorities notified Miss Carr, about two weeks after Woo's arrival, that she had died, they said of a broken heart. I have always thought they could have spared her the news, if not of the death, at least of the cause.

The little dogs had gone their way, some naturally, sadly, it is true, as in the case of all the pets we hold dear. The rest had gone as gifts, to homes where they had been longed for, and where love was waiting for them. Miss Carr knew how it would be without them, but she knew, too, they would be happy in their new homes, as soon as they became settled. The few budgies, the English doves, the one spaniel that were kept seemed a trifle. "Any fool can feed a dove," she said! But the sniff that accompanied the remark took the sting out of it. Miss Carr had for some time tried to keep the pets with her, but it is surprising how few people understand the care of animals.

Miss Carr's home seemed' utterly different to me without them. Only the sparkle in her eyes was the same, and it was often dimmed out with the pain she had to suffer. Often her hand would drop over the edge of the bed to pat the little head that was not there. Ginger Pop had almost reigned there for years. Or a choice bit of her dinner would be cut off and set to one side, for a minute or two, before her eyes would go shiny. (CoCo was a fussy eater and had to be coaxed the last year or so.) She would remember, and slowly mix the bit in among the rest on her plate and set it aside on the tray. A home that has always been full of "creatures," is like a home bare of furniture without them. And a heart that is suddenly stripped of them, is like an unlit stove on a winter's day; no warmth, just little

shivers and chills are circulated from it. The very fact she said so little made the loneliness and longing so clear.

The day before this picnic, we had been out for a walk, along the top of the same cliff overlooking the sea. The tide had been out, a group of children had been playing in the sand, digging holes, making sand houses, burying each other, playing, as children have played for years, in the sand. But they were gone, when we had reached our vantage point, far up on the cliff. The sandy beach resembled scar tissue from away up there; the holes were like open wounds. We did not linger; though very little had been said about the state of the beach it had impressed itself in our memories.

Today the tide had been in and had gone out again, smoothing out all traces, leaving only its own pretty ripple, like little congealed wavelets in the sand. "Look, Child," said Miss Carr, "see the sands? All laid fresh and new, yesterday's upheaval erased completely. If our lives could only be as simple as that. There is a story there in the sands, but I am too tired to find it. Think it over, Baboo; some night we will swap our story of the sands."

We moved on, still missing the little dog tracks that were not there.

The wind continued to blow, this time in our faces, as we made the return journey, past the observatory on the big hill. Miss Carr joked about the type of sail she was going to invent, to put on her wheelchair, to make our trips easier for me. In the distance, coming towards us, down the hill, was a large policeman, walking slowly, evidently deep in thought. I had

been pushing on the hills for some time and was breathing pretty hard. Miss Carr suggested I stop a while to rest, but I was not tired, just puffing. To make the time go faster and take my mind off the push, as she always tried to do, she started to joke. The big policeman was still some distance away. "When we get our sails, Baboo," she said, "it will be hard on poor old policemen like that. Imagine *his* tired old flat feet, trying to catch us, as we tear along breaking all restrictions!"

As we passed the big man, he smiled at me, nodded and touched his big policeman's hat to her. Then he turned and fell into step beside me on the steep hill. Taking hold of the chair, he said, nicely, "May I?" His manner was gentle. He talked to her about the condition of the pavement, the size of the swans in the park, anything, as he continued to push her, with ease, up the long hill. Mom hardly spoke.

When we had gained the top, as he turned to resume his unhurried way, I thanked him, and Miss Carr said, "Officer, I think you have beautiful feet." That was all. I am sure he smiled. He touched his cap again, and continued down the hill. Often I have wondered what it was I missed by not hearing her "story of the sands." My presence was needed in the East so I never got a chance to hear it.

CORKS, PLUGS, AND "STOP HER"

CRAZY titles you think? Well, read on. You will find that these, like everything else even remotely connected with Emily Carr, if given a name by her, have been very aptly named.

Have you ever been confined to your bed by illness? Then you will know how you have groaned inwardly at the thought of another long day to be got through. When friends are busy and the family at work, hours drag so. It is much worse to be confined to your bed, not absolutely ill, but ailing and uncomfortable, and be visited or, as Emily Carr would say, "attacked" by people you know slightly, or by those for whom you have no particular liking, and nothing in common. They invariably stay on and on, tapping their fingers, smoking till the air is blue, swinging their feet, or chewing gum, and talking! Poor Mom, she had them all down pat. Though they were not funny to contend with, it was funny to hear her describe them! During the three-year period which she spent in bed, she had had them all, and her descriptions were good movie material!

The mousey little people come because they feel it is their duty to you, or your mother, whom they may have known years before. They come and sit, and shuffle their feet, wiggle

in their chairs, till you, in desperation, point out the little room at the end of the hall! They twist their gloves, snap their purses, consult their watches, only speak when spoken to, but never go. In both these cases, hours go by, while the patient's temperature steadily rises.

Because it was too hard on Miss Carr to be left at the mercy of the public (who often have no mercy) when she was ill in bed, Mom and I worked out a plan. She had made many new friends, of course, since I had moved East, so I had no way of recognizing the real friends as they came to the door to see her. So, the visitors would be ushered in, and at once our plan would go into action. If the caller was welcome, Miss Carr would say, after the greetings were over, "Well, this *is* very nice." That was my cue; all was well and I was to put the kettle on.

But, if she asked right away, "Did you find the cork?" then the visitor was a "stayer," and steady talker, and Mom needed help. In these cases tea was taken in as soon as it could be made, then in a short time I would enter again and say I was sorry but my patient had to rest at *that* hour, no matter what hour of the day or night it might be!

It was nearly the same procedure when a stranger (to me) called. At once I would be asked about the "plug." The plugs were worse than the corks. They got no tea.

By the corks and the plugs, you knew them!

As the day for my return to the East drew near, we inserted advertisements in the daily paper, in the hope of getting good help, which I could train a little before I left, to make it easier

for Miss Carr. We decided on a nice, big-boned English girl, slow, but nice and clean. While I was there, things went along smoothly, but the letter that followed me home was funny. The girl had been schooled, satisfactorily, I thought, in our "plug" technique.

One day a woman of means who, it turned out, was a prospective buyer from the States called. Miss Carr was meeting her for the first time, with, as it were, the best foot forward, even if it was in bed! The guest was asked to be seated. Then the girl turned to Miss Carr and asked clearly, "Ma'am, is this one a plug?" nodding her head in the guest's direction. No pictures were sold *that* day.

Another English maid had the nicest skin I have ever seen, but Mom says in England all the skins are nice, due to the climate. *Our* faces were red most of the time she was there, and it was not in any way her fault! She was one of those who drop their "h's" and often when we put her sentences together, dressed in their "h's," the meaning was not what it had sounded like! If the puppy got out, she would call, "'Oops, watch, watch your blinkin' neck, the ruddy pup's out!" And "Oh crikey, I'm after gettin' a blinkin' blister on my stutterin' 'eel."

Miss Carr enjoyed this one (most of the time), but tea was rationed then and drinking tea was Dora's favourite indoor sport! And she was untidy about her dress, slip showing, things hanging; it upset Miss Carr's artistic sense to have things continually untidy.

Miss Carr was not one to complain, and, unless she was very ill, she preferred to look after herself. If someone called

125

just to gossip (she hated gossip), or to find fault with things in general, she would chuckle later about how she had turned her visit into a tonic, and how she felt a lot better! She worked it this way, and only on people who, as she said, "had it coming." When a gossipy caller arrived, Miss Carr would wait her chance, then start, and relate all her aches and pains and troubles, the ones she already had and those she was afraid she might develop. All pills and tonics were described in detail. Gossipy people are never sympathetic or interested, or she would never have done it. She said the complete indifference displayed by the caller, even though it was what she expected, never failed to get her goat, so that it acted like a tonic in itself, and she ate and slept better, after such a visit. When I asked, in fun, if it wasn't hard on the callers, Miss Carr replied, with her chuckle, "Not on that brand." But she added, "Do not let it backfire; if it happens the visitor *is* all sympathy, you will probably end up both in tears!" Her warning is well worth heeding, but it should not be hard to pick the type, and it would be rather fun.

APRONS OR PINAFORES

DURING the war years, Emily Carr, like the rest of the world, had trouble trying to get, and keep, good help. It was at this time that her heart was so bad. She was supposed to rest; but it is impossible to rest if things in the home are not going smoothly. When someone stays in bed it does not mean she is resting! A "homebody" is not able to lie and rest if plants need watering, or a budgie needs gravel. And Emily Carr always said sleeping pills did no good if a kitten was crying outside the door.

Every week during the four bad years, I received two or three letters from her, depending on how she was feeling. They were all very interesting; some were funny, and some sad. Some came from her home, and some from the hospital or nursing home, depending on how she was at the time, but they always came. There were a few from her, written for her by her nurse, when she was too ill to do more than dictate.

Every few months they would contain the same little bit: "Ads. in again." The constant changing was hard on her. The spate of questions, "Where is this?" or "Where is that?" can be very wearing, especially for an active person, suddenly

confined, who would find it much easier to get the article than to waste hard-to-get breath in the telling where it was. She dreaded the interviews. Miss Carr had her own names for all the maids, privately that is, and by their names you knew them! Some I remember were, Nimble, Dusty, Muddle, Starchy, Chuckles, and Scorchy (this one was bad!). Some were very good, but the good ones were always being looked up by former employers and offered more money, so they never stayed very long. The poor ones no one wanted. If she wrote me of a new one about to start, who had not yet acquired a nickname, she would then refer to her aprons to describe her; and it is funny how right she generally was in her reading of them. It would be something like this: "Good sensible wrap-around apron type," or "frilly little pinafore, no use I'm afraid." She said many times that when they came all dressed up for the interview she wished, instead of letters of reference, they would produce their everyday aprons!

When the resting first started, there was still some hope of keeping a few of the pets. The advertisements stated plainly that lovers of animals only need apply. But some of the maids she got did not know the meaning of the word *animal*, I am sure! One, for instance, took in the breakfast tray, on the first morning, asking Miss Carr, then, what to do next. She was asked to feed and water the English doves, which were kept in a glassed-in end of the veranda. That was that. More than an hour went by. Not a sound was to be heard from the veranda. The phone rang, and continued to ring. Finally, Miss Carr could stand it no longer. In spite of all the doctor's warnings,

she got up, put a blanket around herself, and made her way to the veranda. Imagine her amazement, anger, and disgust, to find, huddled down in the corner of the doves' cage, this "fond of animals" new maid! She had entered with the food, the doves, glad to get it, had "cooed" as doves do, and she was then too scared to walk out! I am surprised Miss Carr did not leave her there. I never did hear how she got back to bed!

Some of her letters to me, written while Pussy-Foot was with her, were really funny. They would be going along neatly, and suddenly across the page there would be a great slithery line or, at times, a big blot. That would be when Pussy-Foot appeared, suddenly, at her elbow. She moved about without a sound of any kind. Always Miss Carr was very punctual. Once a routine was established, and proved satisfactory, that was the pattern that was followed. The day, at Miss Carr's, started early; fires were lit at the same time every morning. She was awake herself, so naturally, being bedridden, sounds were very important to her. After she had moved from her big home, into her sister's flat, the kitchen was next to her bedroom. It was quite natural, when seven o'clock came, to listen for the stove's clatter, the clamour of the pots. There would be no sound. By the time she was quite on edge, the adjoining door would open soundlessly and the coffee smells would announce breakfast, all ready to be served. Funny though it seems now, it could be very annoying. Miss Carr had, on occasion, had specimens of the noisy, dish-breaking variety, which had caused (and received) their share of grumbles, but Pussy-Foot cured her of the very quiet ones!

"There is no accounting for humour," Miss Carr said to me one afternoon when I asked her to tell me of some of the funny things that had happened. Some of the little stories escape me till something happens to remind me. One I remember clearly.

Rent Rant was her name for this one; if it reminds you of something, I think it is supposed to! She had been with Miss Carr only a week or so when this incident took place. Miss Carr had been a little better, and able to sit up for a while in the afternoons, in her studio where she had been working hard on a special picture of an Indian image, in which the one eye was enlarged and impressive, the other ignored completely, as the Indians are wont to do. She had been anxious to get it done for some time, and was so pleased one day, as she stepped back into bed, exhausted but happy, that it was finished to her satisfaction. Relaxed, she slept a little while, and awoke to find her "helper" of the moment, holding the picture up before her, with *two* eyes! "There, 'e can rest now, Ma'am, I've done it for ya." She certainly had! There was the picture, complete with a second eye, the wildest looking eye, quite yellow, but as the woman said, there were so many colours used in the picture already that she did not think it mattered much which she used, and it was, she said, a very "purty yallow!" Poor Miss Carr, she was quite speechless—with gratitude, this woman thought! "Oh, it's all right, now don't be thankin' me, it's the first time I've done, I daresay it'll be the last, but it's lots of chairs I've done in me time." Remember now her name, Rent Rant!

Mom told me long after that she had had doubts, right from the start, about this helper; engaging her had been, she

said, like delving into a book that has no cover. She wore *no* apron!

In the old days, when Miss Carr was well and strong, the aprons we loved best were the big red oil-cloth ones (made from the old kitchen table covers), which we wore when washing the dogs, or weathering the clay. As both these jobs were done, or started, down in the garden, I was especially fond of them. The dog washing was at times very funny. We never washed the monkey; she kept her own little body clean, and heaven help any unlucky little flea, if he should happen to jump from one of the dogs to her furry little back! But Woo had a lot to do with the bathing of the dogs. Miss Carr had a bottle of liquid soap that came from the veterinary for the express purpose of washing dogs. So, anything at all that came in a bottle, in any room of our house, or from the open window sill of any neighbours, was in jeopardy; but only on the day the dogs were being washed. Woo never seemed to pay the least attention to a bottle, but when the job was started, she always knew exactly where a bottle was. As sure as we became engrossed with our task (and with from twenty to thirty dogs to do, it was easy!), the little monkey would slip off her collar and be away in a flash, in search of the bottle she had in mind. She would try the cork, or screw top, before carrying it back, making sure it would undo for her, then she would do it up again, slip back practically unnoticed, and before you could blink an eye, into the sudsey water along with the dog, would go, maybe a bottle of ink, or ketchup, turpentine, once even part of a bottle of good wine! And she would reach over the

edge of the tub and slap their wet little bodies, her eyes screwed up tight! She never did this unless they were soaking wet, then it made resounding little smacks, that really did not hurt them in any way, but which did infuriate them! She would sneak up as close as she dared when they were taken from the water. She had all manner of tricks up her hairy little arm. If the dog gave itself a shake, in time to splatter her, she nearly had a fit!

Yes, there were a lot of different aprons, for all sorts of jobs, but it was the big rubbery wrap-around, tie-on-tight ones that we loved the best.

PILLAR TO POST

WHEN as a child the urge to draw and to paint overtook little Emily, it was so strong that she was not content, as most children are, with a mere paint box and a sheet of paper. Certainly she had her small box of paints, but this had to be kept in a larger box, professionally, and her paper was even then pinned to a board. Her sisters, all older, used to tease her, saying that all real Artists wore black beards!

Miss Carr could never remember, years later, when it was that the urge to draw first "hit" her. It must, she said, "have come built in!"

But you can see that her supply of boards, boxes and so on, would soon become a problem, in a home already full of little people and their equipment. The bedroom Emily shared with her gentle, very feminine sister was not the place for such bulky material, so at the age of eight little Emily was moved to the end of the sewing room. She loved it there, where her beloved Mother's things were all about, even if her Mother couldn't always be. Emily, even then, could draw satisfaction and comfort from her surroundings. Her memories of hours spent with her Mother, or in her lily field, were wonderful to

hear about. Yet they were absorbed, in a large measure, before she was of school age.

A year or so later, with big sisters very clothes-conscious, more room was needed there, so the little artist was banished to the old pantry. She was past nine now, and well equipped! She was the proud owner of an easel, home-made from the longest pieces of the branches her father had trimmed from one of the garden shrubs. Though Emily and her father had been very close when she was small, she was nine now and even at this tender age she resented her father's dictatorial methods; her own personality was too strong and she could not be driven! So, she made her own easel, independent even then.

The one window in the pantry was small, and pots of this, and jars of that were always being set there, on her equipment, to cool or to set! Most inconvenient, for an artist of almost ten!

The cow shed loft was all that was left. Emily had been eyeing it for some time, but as she had already been getting in trouble for spending so much time with the cow (who was her best model), she hated to put her want into words; a big No is so final! She used to follow the big bony cow about and draw her from all angles, as she did also the hens, the rabbits, the dog, even the man who helped to look after the animals, though she said, "He was not nearly so much fun, you always knew where and how his ears would be!"

It was after her father had seen some of these drawings that permission was given to use the loft. Many years later, when she was quite grown up, in her late teens, she returned again to this loft. Windows and shelves were then installed; but on

this first quest for a studio, it was simply a loft, complete with dust, spiders, mice, and the cow's hay. But, partly because of the surroundings, it was almost private. So, anything else could be overlooked by an artist of ten. She tidied up, had the things all handily around her, had a room all to herself! She loved the comfortable chewing sounds of the cow, from under her. She was settled at last, as she said, "after years of being shifted about, from pillar to post!" Children hate that feeling; they want to be secure in everything.

Years later, when Miss Carr had the House of All Sorts built, she had planned and longed for an adequate, useful studio for years. The second storey of the house had been carefully arranged for the big studio and her living quarters. Up in the eaves at the end of the studio was a dear little room which was her own bedroom. As it was her favourite room, and because she was such a generous person, she turned this room over to me, for the seven years I was with her! I loved it too. On the ceiling she had painted huge Indian birds of war; they extended from wall to wall. In the night as the breezes swirled among the leaves of the big tree outside the window, it was as if the huge birds were ruffling their massive feathers. I was eleven when first I stayed with Miss Carr, a night or so a week at that time. When I went to bed, she would say that her big birds would care for and cover me, as the robins had covered with leaves the babes in the wood! The big casement window was low, nearly to the floor, and as I lay in bed I could look out into the tree, and beyond it, out, and out, and out into the stars. They would seem to draw near, to listen,

too, to the rustle of our tree and the ruffling of the feathers. You knew then why it was her favourite room! The big tree, with its numerous little nests of secrets, made rippling motions all its own, told its own little story, so well that even the soft air trembled, and added to the whisper and the rustle. The story was so delightful that the end never came, it went on and on. It was not all imagination, because Miss Carr heard it too, when she was there in the room alone. Could it have been her vivid stories of the long wakeful nights there? Some dreams are so lovely they ought to be shared. But how many older people would take the time to phrase them in such a way as to hold the interest of a child? What comfort they would give if they did! Our worlds are largely "make believe," our souls are full of lonely places. These little "night stories," as she called them, were no common happening; they were so marvellously precious that if I had no other reason to give prayers of thanks, I will always be thankful that at an early age I was able to know and understand Emily Carr. Love, usually, must be deserved; it must be sought. It makes the giver, as well as the receiver, rich in understanding and wisdom. When I was only twelve, it made me old in emotional responses; now, past forty, it keeps me young in imagination. "Think, Child, think," she would say to me, when I was being stupid about some lesson that had gone badly. "There are possibilities for greatness hidden in each of us, impulses we are not aware of, qualities that could lift us to great heights. Yours are there somewhere." I was never quite sure if I should joke at these moments. Her saying, "If

at first you do not succeed, try a different receipt," seemed to fit so well, and I was sure *I* was the wrong ingredient! Her gentle, apt sayings, leaving always the feeling I was capable of much better work, her sarcasm, would leave a twinge of guilt and at the same time awaken the urge to compete with the task; it was all that was needed to get the best from any child. Before I left the West, at nearly eighteen, to be married, she said to me, "Always have a pet, Child; a dog can share your dreams, aspirations peculiarly your own; no mortal can comprehend our innermost wants. A pet can save a heart a lot of breaking." These sayings of hers, they march across my mind, as solemnly as the stars march away as dawn comes, but they are warmed by the feelings she left deep in my heart, as the sun warms the skies for the stars' returning.

The little room under the eaves! It was no wonder that this was her favourite or, as Miss Carr said, "mostest favourite" room! Yet every time I stayed with her, if only for a night, she would make it up fresh, and insist that I use it. The first two years after I met Miss Carr, she was my teacher, in art and modelling. As our relationship developed, the teaching was only an incident. She was like a fairy Godmother, complete with animals, whom I loved completely, a childish worship if you like, but she returned my love. After the first year, I was her guest from time to time, casually, but after two years she asked me to move right in, and the small room was then known as "Baboo's eyrie." She never used it again, after I left the West to be married. "All things come home to roost, Baboo; it will be ready when you come," she said.

137

But before this, when I was a casual, once-a-week-or-so guest, when she moved out at once as soon as I received permission from my Mother to stay, it was an honour! The guest room was a dear little room, off the studio, with every comfort and casement windows under more shade trees. What I am trying to say is that when she was so tired of shifting about, how very sweet and generous she was about giving up the room she loved so well, simply because it was so nice! She wanted me always to remember that little room as mine, she said. And I do.

When I would try to thank her, to say how unselfish she was (and children are so poor at finding words for thank-you's of any kind), she would say, "Unselfishness recognizes change and variety as delightful, Child, remember that." Then, it was hardly clear to me, now I am glad I can remember her clear, steady eyes, as she said it.

Most young people, if they stop to consider it, have a horror of growing old, I think. When Miss Carr was nearly seventy, after we had been talking of age and ageing, she said to me, as I sat combing her pitifully thin hair, "Baboo, it is a very wonderful thing; you find as you grow older you are not as afraid as you had thought you would be. A sort of peace grows in you with the years; you do not notice, either, till some morning you awake, to find you *are* old, but the peace is there, all fear is gone." Miss Carr was, we know, an Artist with her brush but, with phrases like this, was she not also an Artist with her tongue?

Once, after months of illness, when she had been moved

138

to the hospital by ambulance, a "shift" she hated, she wrote me saying a new idea had come for the book which she was writing at the time. Miss Carr said it came, a memory out of the blue, on the trip to the hospital. She was trying to prove to me that age is actually not as great a handicap as is generally believed. "Age," she said, "does not seem to matter, Baboo; we seem to need only an inner drive, regardless of age; work is a blessing and a relief. I have taken my eyes from the woods, and put them in my heart. Now I write what they see there." We call it memory! That was when the *Book of Small* was conceived.

Her eyes would be looking at me, into me, and through me, as after a walk I sat and visited with her. The things I had seen would be taking shape in her mind's eye, as I made word pictures in detail, trying to describe them. Even the shading in the green of the ivy, as it clutched the wall, was of interest to her. Each little question, as searching as an early robin looking for worms, picked out all the details. My throat would tighten up, and I would have to stop sometimes, only because she did love it so. Her whole soul would be there in her eyes, full of the longing, and the missing of the green growing things. But the gratitude would be there too, in those great expressive eyes, deeper than any she could put in words. Those eyes affected me deeply. My emotions would become so intense, I would fill up with a loving that couldn't be thought.

After a pause, while I tied my shoe, or sipped some water, or scared a fly that wasn't there, I would continue the story. And the little bud would become two buds, for her benefit, so

that the story would be nicer for her and I could enjoy those eyes, happy again with their green memories.

Sometimes I would have lovely stories planned for her. There was the time the neighbour she did not see eye to eye with had washed, and hung out to dry, a huge pair of fleece-lined bloomers. There they swung on the clothes-line, as out of place in Victoria as a sun suit at the North Pole! The birds, too, were amazed; one sparrow worked all through the lunch period, pulling bits of the cotton fleece off and taking them away gleefully, to line a nest, no doubt.

She would be waiting, wanting to hear of the outside "growings," both animal and vegetable. But often unable to ask. So, turning my gaze to the open window (her window was always open), to shut out the misery there before me, and picturing in my mind's eye those eyes as they *used* to be, I would start.

Gradually, slowly, those eyes would close, her fingers gently loosen their grip, and she would be sleeping, often the first real sleep in a long time, brought on by the memories the stories of green growing awakened, which filled her with a comfort not found in pills. If she wakened before the nurse shooed me out, hours later, she would smile and say, "Thanks, Baboo, you do me more good than doctors, Child." The lump would be in my throat again, this time from gratitude, that she really *did* seem to be better. But I would grin and say, "Now, Mom, don't call *me* a pill!"—and those ill eyes would light up a minute with a reflection of the old time sparkle.

My memories of Emily Carr are like a big, deep pool. The

least stir or breeze sets off rippling motions, remembering to remember dozens of little things, that till that particular ripple was started had been unenjoyed for years. Here is an expression of hers that perhaps does not fit here at all, but which I have always loved. You have heard, no doubt, people say, "as cool as a cucumber?" Well, Miss Carr's was, "as cool as a pine tree."

There were so many little sayings, so full of meaning, that if you took time to think about them, you would wonder what incident in her life had caused thinking deep enough to put them in such careful wording. We know that her problems were puzzles that *had* to be solved. "Often, we learn our songs when it is too late to sing." This one has always upset me; she was so successful in so many ways, yet what was the ambition, or tune, that was missed?

LETTERS

"ANY mail today?" We have said that many times, sometimes almost unconsciously as we hear the postman's rap or rattle. It can be an ordeal, just waiting for a letter that does not come. There can be such a difference in letters; some in only half a page can ease your heart, put your mind at rest; others go on and on, and you know no more when you are finished than you did before it came.

Emily Carr wrote lovely letters. They were generally short, to the point, and as personal as if you were there talking to her. You would never guess, by reading the letters, that they were often written when she was in severe pain.

Each would start off, as letters usually do; if it was written on a nice day, it would waken in her the old longing for the woods again. Even when she had been in her bed for years, she wrote me in the spring: "Old and useless though I be, the old longing still sweeps over me, to gather my brushes, and go off to the woods. To go in, and in, and in. The wind was blowing the papers on my dresser; I turned to gather them, and there was a wrinkled old woman, looking at me from my mirror. Old, Baboo, too old, all old but the longing. Baboo, love, memories,

143

and longings do not age." Do you wonder that I kept the letters? And that I read them over and over? Certainly my longings, my memories, and my love will not age, will never die.

Her news of the West would be all mixed up with her love for it. She was the spirit of the West personified; even without her paint brush, she could describe it to you with all its mystery, passion, its elusive charm! Many of my friends from the East, who were lucky enough to share the letters, or parts of them, grew to love the West, from her clear word pictures of it. As she told me of the changes that had taken place since my leaving, she would speak of the woods, cliffs, beaches, and mountains, as we describe special friends.

Tit-for-tat! Miss Carr loved to get nice newsy letters too, but she was very fair about them. If I had been pressed for time, and had sent her a short letter, her reply would arrive promptly, and to the point! "Your *note* just came, a mere crust! Guess my last was no cookie, I shouldn't expect to toss my crumbs on the waters, and get cake in return—but I do!" Then added in the margin later, very often, "I'm spoilt, Baboo, *you* spoilt me." And *what* kind of letter would you write after that, knowing she was ill, with time going so slowly, her pets gone, but not the missing of them, aching with the want of painting? I worked harder dunking up interesting letters for her, than I did at looking after my family of boys, my house, and the horses. She was in my mind all the time. I would be thinking of a way to tell her effectively of the new colt, even while I was riding, breaking another.

Miss Carr loved books; they were friends to her. We kept the mails busy, sending books back and forth. I would come

across one I liked, and would send it out to her. She would read it, mark with pencil several passages she liked, and was afraid I might have missed, then send it back. Friends here, who had never met her, but who had seen some of her letters, and shared some of the marked books, were amazed to learn that there was more than forty years difference in our ages. We were so thoroughly alike in so many of our likes and interests, that differences in age were never thought of.

On my last visit with her, in the evening, if she was tired I would read to her, if not we would talk. She would tell me stories of her childhood, lovely stories of her Mother and of the little personal things that she loved, but were so beautiful and perfect, the very telling made her sad. They gave me the peculiar ache that comes when one is faced with perfection of any kind. Emily Carr had the ache more than anyone else I knew, because she was able to see perfection in all manner of small things, where it abounds, but is missed by most mortals. She saw it in flowers, in trees, in wild geese flying across the sky, in the wrinkles of an old face, ordinary things most of us do not even see. Often when we were in the park, walking among the flower beds, with our animals, laughing, chatting, at ease, suddenly she would stop, her hand would go to her throat. She would not say a word, just bend down and look. Her eyes would be shiny, then she would turn away and would walk home quickly, not saying any more. *Then*, how she would *paint!* At first I was afraid I had offended her. Then, years later, after I knew the story of her soldier, I thought some flowers reminded her of him, so I was sorry too. I would take her hand, and we would walk along in silence, and,

145

as I thought, be sad together. About the time I was fifteen, these awful, sudden aches hit me so hard that I was afraid maybe I was queer, not like other people. Children do suffer.

At quite an early age I started to attend the local dog and horse shows. If I was competing, I was all right; the excitement and exertion kept me busy but, if I was a spectator only—! I had to stop going, it was too embarrassing. We would be walking about, at ease, knowing almost everyone, admiring this animal and that, when suddenly, there would be a horse so perfect that my knees would turn to water, and along my back-bone would run chilly little ripples. Or it might be brought on simply by a dog looking at me, and there would be Pan, or God, or it may have been a Soul looking at me from those deep beautiful eyes. My throat would tighten up, my eyes ache, and *I* would ache, and, all the time, I was full of an awful feeling that I would weep if I was spoken to! And, though all this was brought on by something so nice that I could hardly stand it, all of a sudden my good time was over. The friends I was with would wonder why, all of a sudden, I had had enough and was so anxious to leave. Then I would want to paint, or write to someone about it, but of course I never did!

The year before I was married Mom was with me, one day, in downtown Victoria, when I was affected in just such a way, by a fine little piece of Dresden china in a second-hand store window!

Mom recognized my trouble at once and she came over and silently took my hand. We walked along for ages, then she quietly and softly started to talk. "Little Baboo, you will

not be a child very much longer, I am afraid. I am selfish, but I hate to see you grow up. I am proud of the character you are developing; the sympathetic perception of all things beautiful. You will never be unhappy for too long, but, Child, you will often be hurt." Then she told me about the times I had seen her turn away from a flower, or something beautiful, and she said that it was the same as the feeling the little china figure had given me. It was like hearing a Bible story, the way she told it! I kissed her right there in the street, and I do not think she cared! We did not go in for kissing, Mom and I; I do not think you often kiss those of your own sex, that you are especially fond of, only on special occasions. Then I really had the ache, it made me feel so *good* to know that people, even wonderful people like Emily Carr, had feelings like mine, about beautiful things.

But, to get back to the stories of her Mother. I would say to her, "Mom, if it upsets you, don't tell me." Then she said, "Child, it does me good to tell you. You love your own Mother, just as I did mine; telling you about her brings it all back so close to me. The pain goes out of heartbreak and memory after years, leaving only the memory and the blessing. And we remember. It is good to have someone we can live these memories over with. They come alive for us, the long nights stop being lonely. We *must* keep our memories alive; mine do not hurt any more." Her gentle, quiet way of saying things like this made me feel that I really was helping her, that in some way beyond my grasp at the minute, the *give* was not all on her side. As I left her, when sleep was ready to take over, "Sleep well, Child," she would say. "It is nice you are here, it

147

is so easy to grow young again, with you." You see, when I tell you of her generous nature, the giving was not always a gift, carefully wrapped! Her ability to be grateful to you, for something, that maybe you were thinking, and to let you know she was grateful, without upsetting either of you, a soul has to be very generous to accomplish it!

Before she was ill and had to leave her big studio, we would talk in the long evenings, before her big window on the clear nights, in front of the grate on the stormy ones. "It does not take long to pass an hour," she would say, with her chuckle, as several passed by. She would get into bed finally, and I would go in and sit on a stool, and still we would talk, and plan for the future. Then the sleep, which she was sure had missed her, would cuddle in beside her, and she would fall asleep in the middle of a tale about how her Mother had cured a neighbour's sick baby. I would sit a minute or two to let sleep really take charge, get up quietly, and try to sneak out, but before I could open the door, one sleepy, still merry eye would open a crack, and "Thanks, Baboooooo! Blesssss!" My own dreams would be all piled up, in my little room under the eaves, hardly able to wait till I got into my bed.

I am afraid I have been far away from the letters I was going to tell you about. But her letters are so much a part of her, they bring her back to me vividly. Even thinking of them, I seem to relive the stories of her that they recall. She was so very right. The memories *do* stay fresher, if we are able to retell them from time to time. In this way we are able to keep our memories alive, in a great many hearts.

TREASURES: WE ALL HAVE THEM

WHAT do you hold most dear, in all the world? Have you thought about it? You should, and I am sure you will amaze yourself with your reply. Almost always, anyone who is asked this question will, after a minute's thought, give an honest answer, and name not the family jewels, or the sterling silver, but something held very dear for sentimental reasons. Often it cannot be pinned down to any one article, but may be a collection of them with a cash value of perhaps five dollars!

You must know, then, what it was like for Emily Carr, who lived alone most of her life. She had always had a place of her own and she always had had her own private little places for storing away carefully the treasures, both big and small, gathered through the years. Her home had plenty of cupboard space and many drawers; things were put on a shelf and pushed well back, or in a drawer and covered over. It was a home with one woman, no men; and though things seemed a muddle to anyone who looked in, she could lay her hand on anything that was needed. The treasures gathered over the years. Miss Carr was a busy person who did not indulge in yearly cupboard sorting; so, things accumulated.

149

Her collection of pewter was beautiful. She loved pewter and had gathered pieces from Europe and the States, as well as from all corners of Canada. This, with the silver and hand-painted china that she treasured, had nearly all been asked for plainly, mostly by distant nieces for whom she had very little use. "They can't wait till I go, they want it now," she would say; "but I'll fool them; I'm not going yet a while." She had little use for family tradition, among our people that is. "Our closets are full of rattling disgusts, that we are ashamed of, that we try to hide. Why? The Indians, now, they are honest. If an ancestor was bad enough, he is upside down, maybe, but he stays there on the totem, out in the open, for all the world to see." She respected these traditions.

Imagine her situation when she was taken so sick, was not expected to live, and knew it. She was in hospital, where all the nurses and staff were strangers. Her own pets and loved things, her personal treasures, were at home, safe enough for the time being, but wondering about them must have been awful.

She had her nurse write to me in the East. Our hearts are pretty stoutly made; if they broke from feeling, that letter would have broken mine! She did not mean it that way; she was trying, in spite of her illness, to put a smile between the lines for me! The words were so definitely hers, but not the writing!

It was only a note, which said, "Come west, Baboo. Your old Mom needs you. I am a piece of driftwood on the shore, of no further use to anyone, not even myself. You have raked my lawn clean many times in the past, come gather my leaves for me now. Ticket following."

150

I cried as I hurriedly packed my things. My poor husband was so cross with me. "What does she mean?" he asked. I only half knew. I could not tell him, or put it in words. The trip took six days then; now you can fly in one!

She was still a very ill little lady when I got there, but she was sufficiently recovered that she had been allowed to go home where she was confined to her bed. The first day or so we hardly talked; it was so good just to be with her again. We sat, and I held her hand as she lay there, relaxed again, after many bad days. She hated the bed, she hated not being able to do more than move. When you are with someone you love absolutely, words are often unimportant. In her room, she had a canary and a love bird; some doves still occupied the little glass house on the veranda, but all the animal pets had been gone for some time.

I had been there about three days then, and not a word had been said by either of us, about why I had been sent for. One evening it was stormy, and blowing very hard. We had the house closed up tight, a nice fire going, and I was reading over to her one of her own manuscripts. Suddenly she interrupted my reading with, "Enough of that old thing."

She began then speaking quietly of her Indian friends. In a roundabout way (this added to my discomfort, she always had come so directly to the point!) she brought up the Indian burial customs. Religion is fine, she said, as far as it went, but some aspects of it were too commercial for her tastes, especially funerals, and all that went with them. From the time the soul became restless till the leaving was over, the fuss and social

upset death caused, she said, made it, instead of a restful going, a thing to be dreaded. This was not the case with the Indians. When an illness struck, after everything had been done that could be, and the end was coming, the family gathered, not as is so often the case in our families, to haggle over treasures, but, while life lingered, to scare and ward off devils. This assured the soul going in peace, and helped to hide the heart-break; a lot of sorrow could be, and was, among the howls! There were no pent-up emotions at the bedside, and this made the journey easier!

Then, all the belongings of the dead were gathered up, and buried with him, in little burial houses, or in boxes in the huge cedar trees, depending on which tribe he belonged to. The treasures remained with the dead for ever. The bodies were close to the surface of the ground, and helped, they firmly believed, to replenish the land. They could, and often did, give a valued treasure to a friend, when they knew of their going in time. But afterwards, nothing was claimed or given away. Often, in fact, the nicest thing they had ever owned would be given to them as they were breathing their last, so that they would not enter the next world empty-handed!

"What I am getting at, Child, is this," she said. "I am no Indian. I have no way of sorting my things. Will you be my sorter?" I went through drawers and boxes, there, beside her, for hours it seemed. Many times she wept as from an old trunk I would carefully unwrap all manner of things. There was a child's prayer book (she gave me this), a pair of men's large old gold cuff links, worn small books of poetry, bits of jewelry,

mostly broken, worn small dog collars, faded pictures, a dear little mesh purse, several little silver snuff cases (these she also gave me), and lots and lots of other things. There were many bundles of letters. These we sorted; some were packed in boxes, a few we burned.

Then she said, "Baboo, there is one last thing that I ask you, one last chore for you to do for me. These things would be of no value to anyone else, but they are a part of me, my past. I cannot bring myself to burn them. Take them, Child, out into the woods, and bury them for me, a box at a time, where they will rest with the trees, through the years. My spirit will rest with them. Bless you, Baboo."

It is hard for me to tell you this. So many may not understand, could never understand, and it should be clearly understood. Her love and deep feeling for the western forests was so real and vital. It is among them that her treasures should be.

I cried as I dug. I cried as I did every time one of my pets had died, and I buried it in the dusk of the evening. Why, I wonder? Often the dead are better off. And these little boxes, I tried to tell myself, they had not died. Or had they? Was that why I cried?

Emily Carr said, "We cry for ourselves; we know suffering for our loved ones ceases, but we feel we will miss something in life." But she too cried, when her loved ones or her pets died.

I have heard so many nice things about Heaven, and seen pictures of Artists' conceptions of it, but I would like to be sure that there are many trees there, in a corner maybe, for Mom.

Treasures? We all have them. Mine? I met Emily Carr, one lucky day, and I thank God.

153